How To Create Great Informal Portraits

How To Create Great Informal Portraits

by Bill Thompson

AMPHOTO BOOKS
American Photographic Book Publishing
An Imprint of Watson-Guptill Publications
New York

For my parents, Rosinha, Anya, and George

Copyright © 1982 by Bill Thompson

First published 1982 in New York by AMPHOTO,
American Photographic Book Publishing,
an imprint of Watson-Guptill Publications,
a division of Billboard Publications, Inc.,
1515 Broadway, New York, N.Y. 10036

Library of Congress Cataloging in Publication Data

Thompson, Bill.
 How to create great informal portraits.

 Includes index.
 1. Photography—Portraits. 2. Photography of
families. I. Title.
TR575.T54 778.9'2 81-22821
ISBN 0-8174-4000-3 AACR2
ISBN 0-8174-4001-1 (pbk.)

Manufactured in U.S.A.

First printing, 1982
1 2 3 4 5 6 7 8 9 / 87 86 85 84 83 82

Contents

Introduction: Seeing

The world is substance in motion. Photography is largely an editing process: unlike painting or drawing, where the artist begins with blank paper or canvas, taking a photograph means imposing a frame on a small part of what already exists. We seek to hold on to what we experience, especially with our family and friends. Photographs do record our experiences; but more than that, you as the photographer can *interpret* those experiences through your photographs. Techniques of focus or composition, for example, can help you emphasize your subject in relation to the environment. You can make your own statement about your subject by using the methods discussed in this book to create great family portraits.

The Photographer's Eye

Educate your "eye" and eventually you will see good photographs even before you raise the camera. Part of this education comes from contact with fine photography. Try to emulate great images, both technically and compositionally. Just as ambitious athletes practice with more advanced players, you also should keep your sights high. Even if you aspire only to a higher form of "snapshot" photography, being aware of significant work will improve your own. You should become acquainted with the work of such people as Robert Frank, Margaret Bourke-White, Paul Strand, Walker Evans, Harry Callahan, Dorothea Lange, Andre Kertesz, W. Eugene Smith, Henri Cartier-Bresson, and Edward Weston. You can also learn much from examining the work of commercial photographers such as Richard Avedon, Hiro, and Guy Bourdin.

The more you see the more ideas you'll have. And don't limit yourselves to photographers. Look at the work of such fine artists as

Magritte, Gauguin, and Edward Hopper. Get to know the sculpture of Giacometti and the illustrations of Norman Rockwell. Even comic books often introduce dynamic ideas for composition. Look at children's books done by Winsor McCay, Maurice Sendak, Rose Ostrovsky, and Edward Gorey.

Beginning to Photograph

When you begin photographing it all seems very confusing. The camera appears complicated and the effort involved often seems to kill the spontaneity of the scene. Do not become intimidated by the technology. With practice—and mistakes—you learn, and gradually you become more and more satisfied with the results. Ironically, you learn more from failures than from successes. Failures cause you to think more about what you're doing.

After eighteen years as a professional photographer and teacher, I believe that everyone can become a good photographer. Once you understand the basic camera settings and what they correspond to, you are over the major hurdle. Then it is just a question of seeing and practicing. Apart from technical problems, composition is usually the weakest element in amateur photographs. Good composition is based on an innate sense of balance, which can be developed. Only through practice and examination of the results will you improve.

Don't let the new automatic cameras cause you to go faster than your mind. Take your time and think about what you're doing. Push yourself to experiment, once you learn the basics. Always think of other ways you might do the same portrait, and try them out. Vary the angle or the lens; change the depth of field or the composition. Film is relatively cheap, so don't be lazy. Try to be creative and you will be. You learn more by experimenting than by

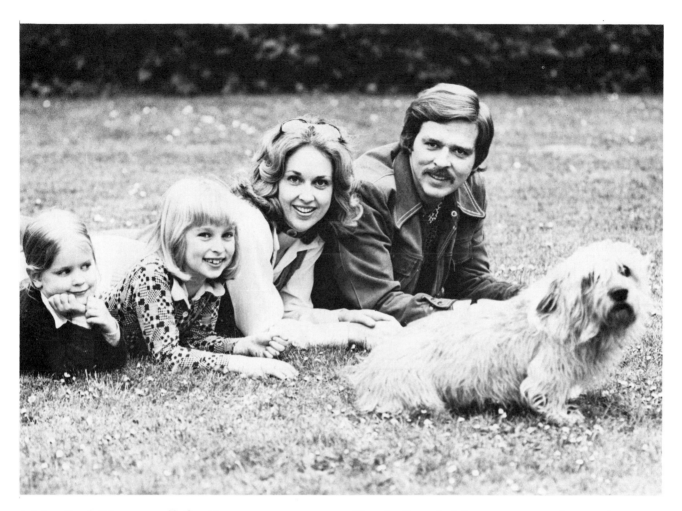

taking "safe" images all the time.

The main thing to remember is that taking family portraits is *fun*. The techniques and equipment are tools for you to utilize in creating your photographs. You don't need elaborate setups. Working with people has its own special rewards: you can use your own perceptiveness and insight to illumine your subjects. Pose the shot to carry through on a theme you have in mind or snap candid pictures for a more informal feeling. Use your camera to explore the subject. You will be constantly learning and experimenting, and you will be surprised and gratified by the results.

You don't need elaborate setups and expensive equipment to take top-quality photographs of your family and friends. All that is really needed is basic equipment and technical knowledge, plus the creative urge to experiment and try new ideas.

Camera Technique

The Basics: Exposure

All cameras do basically the same thing; they focus an image through a lens onto light-sensitive film. The factors you work with are shutter speed, aperture, and depth of field, using the camera's exposure meter. When you have familiarized yourself with the principles behind these elements, you can use them to experiment with creating different effects.

Exposure is determined by two connected variables: shutter speed and aperture. The *shutter speed* determines how long the image takes to imprint itself on the film. Too much time builds up too much light on the film and "overexposes" it, making a light image; too little time does not sufficiently expose the film, thereby "underexposing" it and making a dark image. Shutter speeds range from 1 sec. (a slow speed) up to 1/1000 sec. (a fast speed often used for "stopping" action). Most hand-held photographs are taken at 1/125 sec. or faster. Slower shutter speeds will often cause blur due to camera or subject movement. If you are forced to photograph using a slower shutter speed (provided the subject is not moving), then a tripod and cable release are invaluable accessories to your equipment.

The standard shutter speed for hand-held photographs where nothing is moving is 1/125 sec. Below that speed the photographer risks getting blur. The larger you print the image the more evident any lack of sharpness will be. If the subject is moving at all—for instance, if the head or hand gestures—then photograph at 1/250 sec. For more than gentle movement, use 1/500 sec. or 1/1000 sec. When using a telephoto lens, you should use one shutter speed faster than those given for every situation because of the increased magnification of the telephoto. And any time *you* are moving (in a moving car, for example), use the fastest

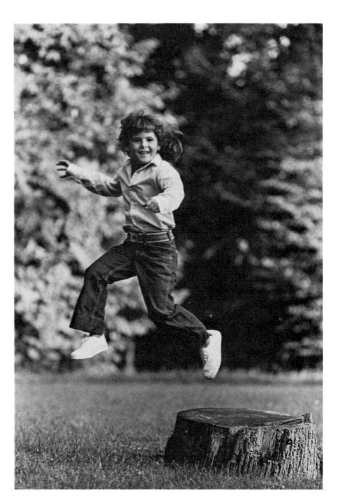

One of the most dynamic elements in a photograph is a sense of motion, but motion is also one of the most difficult things to capture on film. To completely freeze even gentle motion, you should use a shutter speed of at least 1/500 sec. This photograph was taken at 1/1000 sec.

shutter speed possible for your exposure. These techniques will *freeze* the image.

If you intend to use blur to give more of a feeling of action, then you can use the tech-

nique called *panning*. Use a relatively slow shutter speed (1/60 sec.) and move the camera at the same rate as the subject in motion. This will blur the background but keep the subject mostly sharp. Panning is often used in nature and sports photography to give more of a sense of action than you get by freezing the image.

Coordinated with shutter speed is the *aperture*, a variable opening in the lens that determines the quantity of light reaching the film. It is expressed in "*f*-stops," often over a seven-stop range: *f*/2, *f*/2.8, *f*/4, *f*/5.6, *f*/8, *f*/11, and *f*/16. This is a mathematical progression, with *f*/2 letting in the most light at "wide open" and *f*/16 letting in the least.

When looking through a reflex camera you are usually viewing the scene wide open, or at the widest *f*-stop. Modern lenses are designed this way so that the field of view is brighter and thereby easier to focus. When you push the shutter release the viewing mirror raises up out of the way and the lens automatically "stops down" to the preset aperture and then opens up again after the image is recorded.

The exposure meter, usually built into the camera, reads light reflected off the subject and informs the photographer, based on the sensitivity of the particular film in use, what combinations of shutter speed and *f*-stop can be used to obtain perfectly exposed negatives or slides. Then the photographer must choose the best combination. The exposure meter is calibrated to average the scene to 18 percent medium gray. This is usually a good average and will produce good results.

Depth of Field

Depth of field is the area (in a line) in front of and behind the point of focus. The more a lens is stopped down (the smaller the aperture) the greater the depth of field. There is always more depth of field behind the focused point than in front of it. When taking a portrait, focus on the subject's eyes, especially at low depth of field. Depth of field can be determined by the type of lens used as well as by the aperture setting. A telephoto lens has shallow depth of field, while a wide-angle lens has long depth of field.

Any lens will have the most depth of field at its smallest aperture and the least at the widest aperture. When you look through your camera lens to focus at wide open you are seeing the least possible depth of field. This is the proper way to focus. Usually there is a

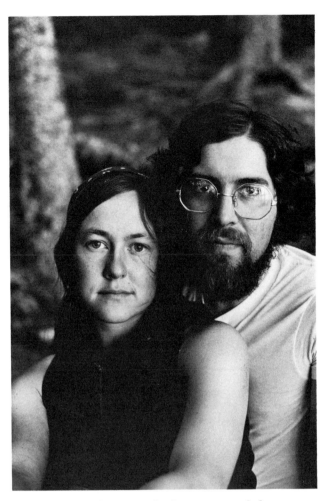

The eyes reveal a person's character, and they are the most important thing to have in focus in any portrait–especially when there is short depth of field. Make it a habit to focus on your subject's eyes, and you will get better photographs.

depth-of-field preview button on the camera to show you what the scene will look like when it's stopped down during the exposure.

The shorter the focal length of the lens, the greater the inherent depth of field for any particular *f*-stop. Therefore a wide-angle lens at *f*/8 (focused at a certain distance) will have more depth of field than a normal lens at *f*/8, which will have more depth of field than a telephoto lens at *f*/8. Most images in this book showing long depth of field were taken with a 28mm wide-angle lens. Because a smaller aperture necessitates a slower shutter speed, a tripod is often needed with portraits using long depth of field.

The problem with judging depth of field using the preview button is that the viewing is not very bright when the lens is stopped down.

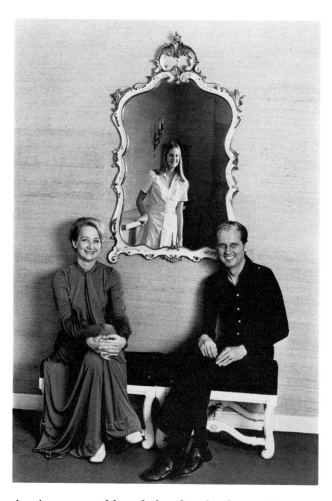

A mirror can add a whole other depth to a photograph. If you want to get both the mirror frame and the reflected subject in focus, you must calculate both the distance between you and the mirror and the effective focal distance between you and the reflection in the mirror. Then set your focus so that the depth-of-field indicators on the top of the lens encompass both distances.

Theoretically you see the depth of field, but in fact you often cannot judge properly. There is another method for judging depth of field: using the scale on the barrel of the lens. When you focus you will notice that the lens lines up with a number denoting the focal distance. On either side of the focusing line are *f*-stop designations. If you look at the number of feet corresponding to those *f*-stop markers, you will have the range for depth of field for each *f*-stop. You'll find that you have more depth of field the more you stop down the lens.

A mirror can be an effective prop in a photograph. To calculate the depth of field when you want both your subject and the reflection to be in focus, check the focal distance for each. For example, if the subject distance is 8 feet and the reflection is 12 feet, then on the depth-of-field scale you want 8 to 12 feet in focus. Set your lens accordingly, choosing the necessary aperture.

Zone Focusing

One of the best ways to be sure of having adequate depth of field in your photographs is to use a technique known as zone focusing, which involves setting the lens to what is called the *hyperfocal distance*. This is very easy. Once you have determined the proper aperture for exposure, look at the top of the lens for the distance indicator markings for that particular aperture, and refocus the lens so that the further marker aligns with the infinity mark on the lens. The other aperture marking will then align with a closer distance (say, 5 feet), and everything farther than this distance will be in focus. This method is handy for candid photography because as long as the subject is farther away than the minimum distance it will be in focus. Therefore, you will not need to take the time to focus.

If you want shallow depth of field, either because the background is distracting or simply for graphic power, then use either a wide aperture or a telephoto lens. The longer the lens, the less inherent depth of field there is. Shallow depth of field will often help when there is a problem with tonal separation, or contrast. By putting the subject in focus and the background out of focus, you will attain the separation.

You must take into account interaction of depth of field, shutter speed, and aperture

when making the exposure. Determine first which is most important for your photograph and then adjust the others using the exposure meter. For example, if you want to stop the action, you will need a fast shutter speed; therefore, if there is not much available light you must open up the aperture. This will decrease your depth of field. If you want only the subject in focus, open up the aperture for less depth of field and then adjust the shutter speed as determined by the exposure meter. This may seem complicated at first, but with practice you'll find that it becomes second nature; you won't have to think out each step separately.

Film
Films are manufactured with an inherent light sensitivity, determined by how many silver halide crystals are put into the emulsion and how they are spaced. The film's light sensitivity is expressed by the ISO number (see box): the higher the ISO number the more sensitive the film is to light. ISO 400/27° is a moderately "fast" or high rating for use in low-

One of the best ways to diminish a distracting background is to throw it out of focus. This can be done by using a telephoto lens (or a large lens opening on a normal lens). The resulting small depth of field makes it easy to focus only on the subject, letting the background go blurry.

light situations. Films that are "slow" with a low ISO (for example, ISO 25/15°) are usually used in bright daylight. The camera exposure meter must be set to the ISO of the film you are using. Be sure to check this setting.

Films have an international rating based on their sensitivity to light, also known as their "speed." Currently we use an ASA number (abbreviation for American Standards Association). Soon the designation will change to an ISO number (International Standards Organization). The ISO numbers are the same as ASA numbers, but rather than seeing "ASA 25" on Kodachrome 25, for example, you will see "ISO 25/15°." The second number refers to the DIN (Deutsche Industri Norm) designation used in many European countries. During the transition period, you may also see the film speed written as ASA 25/15 DIN.

Generally, with any film the higher the ISO the more apparent *grain* will result. *Grain* is the apparent speckled texture of a photograph, caused by the clumps of silver halide crystals that create the image on the film. A lower ISO film will have finer grain. Most photographers prefer to have a higher sensitivity in their film and thus accept the increased grain. Grain can be minimized by good laboratory processing.

Black-and-white films produce negatives, which are then "enlarged" into positive prints. Color films come in two major types: negative (designated by "color" as a suffix) or slide film (designated by "chrome" as the suffix). Negative film is used the same way as black-and-white film—placed in an enlarger to make a positive print. Slide film is processed into a positive transparency, which is either projected or viewed directly. Color films come in either "daylight" (for natural light or electronic flash) or "tungsten" (for indoor lighting). Daylight color film is "balanced" for sunlight and blue sky. Whenever that light balance changes (for instance, an overcast day without sun), there will be a corresponding shift in color cast. On an overcast day there will be a bluish cast. Such shifts in color can be corrected by filters. There are data sheets and booklets to explain about filtering, available from the manufacturer or your camera store.

When photographing indoors, under artifi-cial light, you must use a tungsten film. This is because indoor lights are usually red in color (though the eye does not see it) and the film is manufactured especially to compensate for it. Conversion filters can be used to adapt indoor film for natural light or to convert daylight film for tungsten light. But for most photographers the color film most often used will be daylight film.

In many ways, photographing with color film is similar to photographing with black-and-white film; in other ways it is very different. The addition of color can add a whole new dimension, but at the same time it can distract from the other elements of a photograph. A bright red sweater, for example, can be so powerful in a color photograph that the viewer is not aware of much else—not aware of the composition, the focus, the subject's expression, or other aspects of the image.

With black-and-white film, however, the absence of color leads to the viewer's concentration on other aspects of the image. This makes it easier to see the components that are necessary for a good photograph.

It is for this reason that the photographs in this book are in black and white, that many photography courses concentrate on black-and-white work, and that many photographers start by working in black and white. Once you can take a good picture in black and white, understanding the basic elements of a good photograph, it is easier to take a great picture using color film.

Lenses

Most SLRs come with a "normal" lens. This is the lens that most approximates the scale of reality as seen by the naked eye. Usually this lens is 50–55 mm long. Longer lenses, which take in a smaller angle of view and thereby magnify the scene proportionate to the length of the lens, are *telephoto* lenses. *Wide-angle* lenses are less than 50mm and take in a greater angle of view than a 50mm lens. Standard wide-angle lenses are 35mm, 28mm, and 21mm.

What lens you choose is determined by what scale you like to use. Most "head and shoulders" portraits are taken with a medium telephoto lens, usually 105mm or 135mm. But if you prefer to photograph the environment along with the subject, then a normal or wide-angle lens might be more appropriate. Keep in mind however that the the wider the lens an-

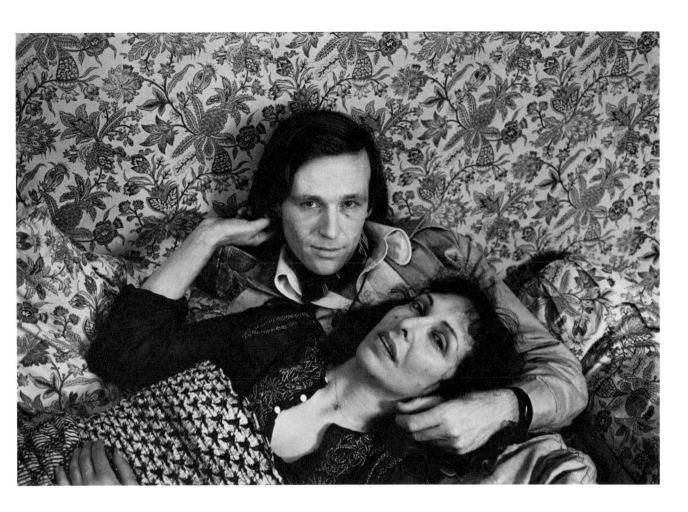

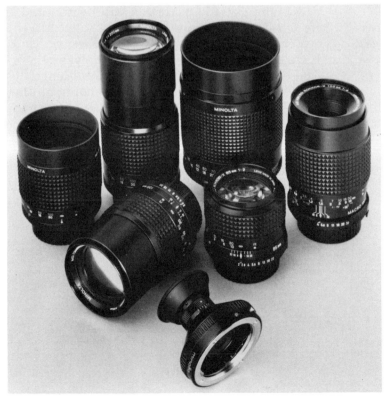

With black-and-white film, textures and patterns take on much more importance than they do with color film. The absence of color concentrates the viewer's attention on the graphic and compositional elements of a photograph.

There is a large assortment of lenses available for most 35mm SLR cameras. Most major camera manufacturers make at least thirty, ranging from fisheyes to reflex telephotos, and some independent lens and accessory manufacturers make nearly one hundred. These "independent" manufacturers' lenses come with different mounts, and you should be sure to get one with the proper mount for the camera you own. Shown here are six popular lenses made by one major manufacturer, along with an eye-piece device that permits them to be used as telescopes without a camera.

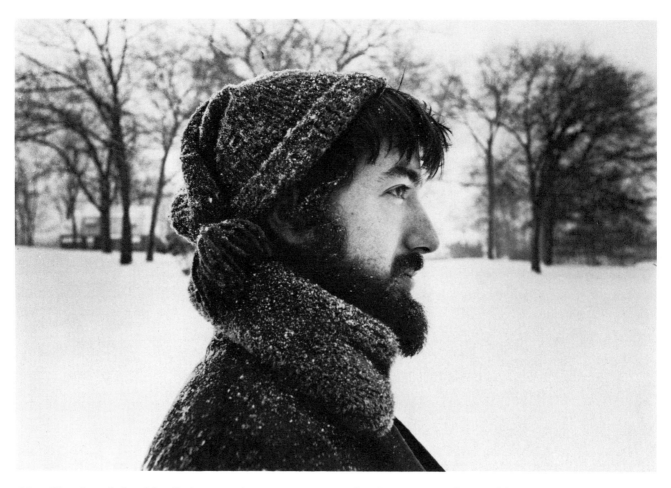

Most "head-and-shoulders" shots are best taken with a medium-length telephoto lens (such as a 105mm or 135mm). This lens allows you to work far enough away from the subjects to let them feel comfortable, while also eliminating the distortion that comes from using a shorter-focal-length lens up close.

gle the greater the problems of perspective distortion. Usually distortion will be minimal for lenses above 35mm.

Very popular today are *zoom* lenses, which have been vastly improved over the years. These are lenses with a variable focal length. They exist in various ranges, depending on the model, and often cover focal lengths more than 100mm apart. They are usually heavier than fixed-focal-length lenses and not quite as sharp. They are also usually slower (having a smaller wide-open aperture). But they are versatile and may be the best compromise for photographers who don't want the expense or weight of several fixed-focal-length lenses.

Lenses are almost always sharpest somewhere in the middle of the f-stop range. Usually $f/5.6$, $f/8$, and $f/11$ are the best apertures. Wide open is usually the least sharp.

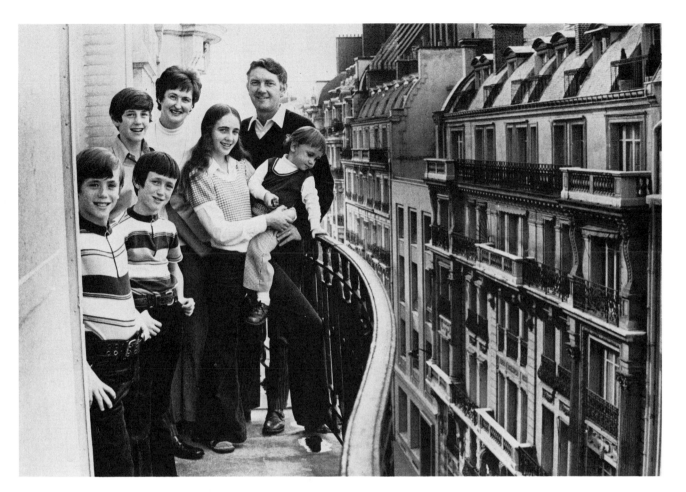

But there is no substitute for testing your own lenses to determine exactly what the best apertures are. Take the same subject at different apertures (using a tripod and compensating the shutter speeds) and compare the results side by side. Most good lenses are comparably sharp at about $f/8$, but the best lenses are sharper over a wider range than less expensive ones. This variation in sharpness between an expensive lens and a cheaper one, however, will not usually be noticed unless you are making large prints, 11" × 14" or bigger.

Always use a lens shade. This will keep extraneous light from hitting inside the lens, compromising the contrast of your image. But use a shade appropriate for the length of the lens. If too short it will be ineffective and if too long it will cause vignetting (blocking of the photograph's periphery).

If you want to include a good portion of the surroundings, or environment, in the portrait, it is best to use a normal or slightly wide-angle lens. If you want all the surroundings to be in focus, you must of course use a small lens opening for maximum depth of field.

The 35mm single-lens reflex (SLR) camera is by far the most popular choice of serious amateur and professional photographers. These cameras come in a variety of types, from sophisticated to stripped-down, and price ranges, and are made by a number of different manufacturers. Shown here is one of the more sophisticated models from one of the major manufacturers.

Another popular type of camera is the 35mm rangefinder. You can tell a rangefinder from a single-lens reflex by the two small windows above the lens, and the lack of a bump (pentaprism housing) on top of the camera. Shown here is a technologically advanced 35mm rangefinder with built-in flash unit.

Cameras

Most sophisticated cameras in use today are 35mm single-lens reflex (SLR) cameras. You look through the lens that will take the photograph when you focus. Modern SLRs often have interchangeable lenses, and usually have a built-in exposure meter. Some people prefer cameras that take a larger negative, but these are always heavier and slower to use. Others prefer a 35mm rangefinder camera, where the viewing is done through a window at the top of the body and not actually through the lens. They are less versatile than an SLR but are easier to focus in low-light situations and often have excellent optics. The rangefinder was extremely popular during the great years of *Look* and *Life* magazines. Because there are few moving parts the camera is very durable. With a rangefinder you often have to use a separate hand-held exposure meter.

Most advanced photographers do not wish to use a completely automatic camera. Though SLR cameras are becoming more and more automatic, the serious photographer will always want to maintain a "manual" capability. The main qualities to consider in purchasing an SLR are durability (consult a professional camera repair person), ease of handling (some systems are easier to focus and handle than others), and the exposure system. For the economically minded serious photographer a completely manual camera with a built-in exposure meter is probably the best choice. There are several excellent models available at a modest price.

For photographers who want an SLR with an automatic exposure and manual capability there are two possibilities. Most prevalent is the *aperture priority* system, where you set the aperture, and the camera then determines the correct shutter speed, even if it is in between the normal settings. When using this system, check that your shutter speed does not drop below 1/60 sec., because camera shake could result. *Shutter priority* means that on automatic mode you set the shutter speed and the camera determines the correct aperture. Most automatic systems are one or the other, and some cameras have both modes. The main advantage of the automatic capability is the ability to work faster. This can be helpful, especially when you are doing candid photographs of young children—who are often in motion. Keep in mind, however, that usually

the faster an inexperienced photographer works, the more bad pictures result. Try to work carefully, knowing exactly what you are doing and why you are doing it.

Often you can obtain excellent equipment at a bargain price by buying it used. Just be sure to have it checked by a professional camera repair shop before you buy. Most reputable sources will allow this stipulation. The Nikon F, which is now discontinued, is a perfect case in point. Though it has no built-in meter it is one of the best-made cameras in the past twenty years. It is a fine camera to purchase used, giving quality at a good price.

General Tips

Have two tripods: a small tabletop one that can be carried in your bag, and a larger heavier one for use in set-up situations. A good, solid tripod is a must for any serious photographer, especially when using slow shutter speeds. Use a cable release so you don't move the camera when you trip the shutter. Using a tripod, you can photograph in almost total darkness with excellent results.

Have your camera shutter speeds and exposure meter checked every six months by a professional camera repair person. Often with use the shutter speeds slow down or the meter goes out of calibration, throwing your exposure off. Consistent maintenance will correct this.

Because of the growing incidences of camera theft, you should carry your equipment in simple canvas bags lined with foam rubber. Don't advertise what you are carrying. And you should have camera insurance.

A good accessory is a hand-held exposure meter with an "incident" light capability. In many of the images in this book the exposures were measured by incident light and a separate meter to ensure accuracy.

Carry photographic lens tissues for use in cleaning off fingerprints on the lens. If this occurs, breathe gently (and dryly) on the lens and carefully wipe it off. Or if you can, use good-quality UV filters over your lenses; these do not affect the exposures but do protect the surface of the glass.

Practice holding your camera steady. Much image blur is due to camera shake or movement. Whenever possible with hand-held exposures use a shutter speed of 1/125 sec. or faster. With a telephoto lens use at least 1/250 sec. for good results.

This 35mm SLR has both an aperture-priority automatic exposure system and manual-exposure capability. All major camera manufacturers now offer 35mm SLRs with either automatic exposure systems or a combination of both automatic and manual exposure systems. (The camera shown has an accessory motor-drive unit attached to the bottom of it.)

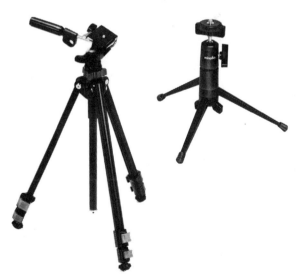

Tripods are a crucial part of any serious photographer's equipment. The small one shown here is ideal for carrying in an equipment bag, while the larger one is heavier and more cumbersome, but useful for set-up situations.

Taking Action Photographs

Action photographs often project more about a person than you can capture in a posed shot. You can also use them as a tool to create rapport with your subject, especially when it is a child. In some situations you can control the image to a certain extent, but you can never predict exactly what the camera will see when the shutter clicks. The movement sometimes results in a serendipitous image that makes a stunning photograph. There are, however, inherent problems in this type of photography.

Generally, movement parallel to the camera is easier to photograph than movement in a direction perpendicular to the camera, because the focal distance remains constant. If you know what the precise course of the parallel action will be, you can prefocus. When photographing children, for example, you can plot two points, one outside either end of the frame, and have the children run from one point to the other, parallel to the film plane. Before the action starts, have them stand in the middle of the imaginary line while you prefocus. This makes your job much easier once the action begins. Because the actual shot happens so fast, you can never be sure what the subjects' expressions were. If possible, retake the picture several times so you will have a choice of images afterward.

Focusing on a person moving toward the camera is the most difficult type of action photography. If you know the route, you can prefocus on a spot and wait for the subject to reach it. One solution to the problem may be using a wide-angle lens, with its inherent depth-of-field capability.

Familiarize yourself with the knowledge and techniques in this chapter, and you are on your way to being a creative photographer. Practice using the camera in different light situations. Take the same photograph but vary the depth of field. Examine your results and you will learn by doing.

One of the easiest ways to focus on a moving subject is to focus on a stationary object or point, and trip the shutter when the moving subject reaches that point. In other words, let the subject move into the field of focus, rather than trying to track it and focus at the same time.

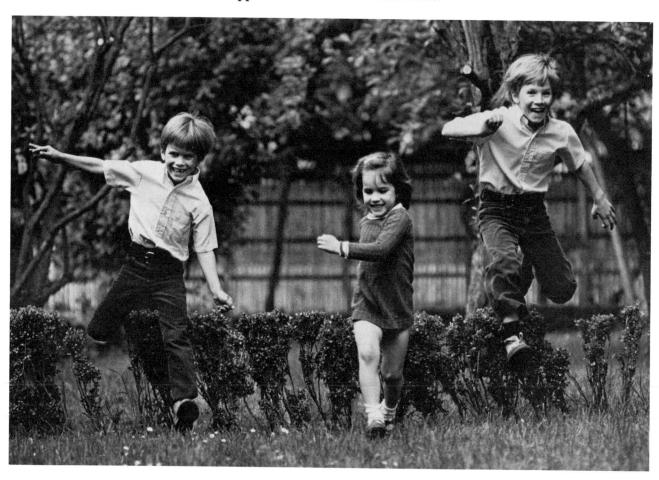

Light and Exposure

Light quality is important. If your object is to flatter the subject, generally a soft, diffused light will be better than contrasty light. Use late afternoon light, preferably in open shade. Even in bright sun you should be able to find shade cast by a tree or building. Just remember to face the person toward the source of the soft light and not toward the tree or building, or you may get unflattering shadows.

The worst light is direct, overhead midday sunlight, which produces contrasty negatives that are difficult to print. It also emphasizes every wrinkle in the skin and causes people to squint. Strong sunlight is good for architecture but seldom for people. The only exception is late afternoon sunlight, just before sunset, when the sun is low on the horizon and diffused through the earth's atmospheric haze. This sunlight is, however, reddish in cast and may be unacceptable with color film unless the exposure is corrected by filters.

Film registers light in a much more contrasty manner than the eye sees, so it is important to begin with soft light. If the scene is already contrasty (midday sunlight, for example) it will be much worse in the resulting negative or slide. There is no harder negative to print successfully than a contrasty one.

Most of the portraits in this book were taken either in late afternoon daylight or with electronic flash bounced from a white umbrella, which approximates soft daylight.

Outdoor Lighting

Light intensity is an objective measurement of the quantity of light that is made by your exposure meter, coordinated with the ISO of the film. The meter is calibrated to 18 percent medium gray and will usually render scenes correctly exposed. Built-in meters measure "reflected" light—light reflected off the subject.

Separate "incident" meters measure the light itself. Instead of facing the meter at the subject from the camera position, you stand in the same place as the subject and face the meter toward the camera to measure the light.

Reflected-light measurement will sometimes be fooled by scenes at a variance from 18 percent gray. For instance, with a very light scene containing snow or beach or an expanse of sky the meter will overcorrect and thereby underexpose your negatives or slides. On the other hand, a dark-skinned person or scene may be overcorrected in the opposite direction and made too light in the resulting image. (Note that the 18 percent gray calibration is one stop darker than a Caucasian face.) Especially in these situations, it is important to have manual capability to override the automatic misreading of the scene.

If you do have a completely automatic system, you can compensate for the meter's misreading by resetting the ISO of the film. If you have an ISO of 400/27° and you know that it will underexpose a particular scene because of lightness or backlight, you can reset the ISO on the camera to 200/24°, for example, thereby adding one f-stop of light. In the other extreme, you could reset the ISO to 800/30°, thereby cutting the light one f-stop. Always remember to reset the ISO to the original number after making the particular exposure.

In portraiture the key light is that on the subject's face, so always compensate to register this light correctly. Whenever you are unsure of exposure measurement you can *bracket* your exposures: choose what you consider to be the correct exposure and then also expose the scene one-half and one full f-stop on either side of the original exposure. Film is inexpensive, and bracketing ensures that you will get a perfect exposure. All professionals do it.

An incident-light reading is less susceptible

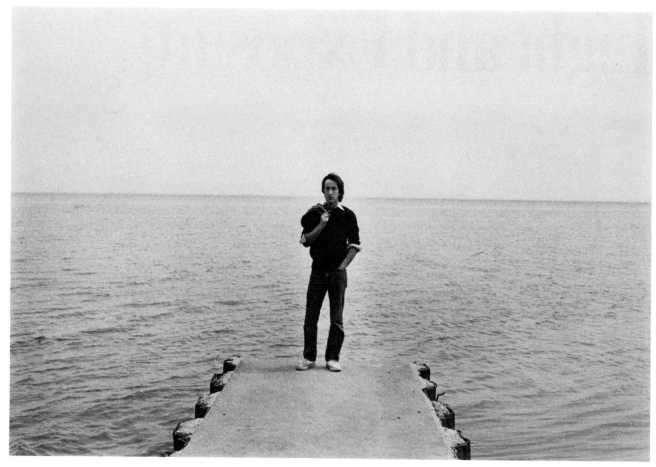

There are certain exposure situations that will fool almost any light meter, and these require manual compensation for proper exposure. When the background contains a large expanse of snow or sky, it is usually best to move close to the subject and take an exposure reading off just the subject's face, hold that reading, then move back to frame the photograph the way you want it.

to error due to tonal variation and therefore is often used by professionals in still and motion-picture photography. When utilizing incident-light measurement, you stand where the subject is and face the camera with your incident exposure meter, measuring the light itself falling onto the subject.

Fashion photographers often use reflectors in outdoor photography. These reflectors are usually white cardboards about 2' × 3'. They are used to reflect light onto the subject's face. This is called "fill" light. Sometimes with strong backlighting this method not only equalizes the exposure but also makes for a more pleasing light. The reflector should be just out of the camera frame and angled

toward the subject. You must watch how the angle affects this fill light.

Artificial Lighting

It is better at first to master natural lighting and then move on to artificial light. The most popular artificial light used today is electronic flash or *strobe*. Any light source when used "direct" will produce harsh, contrasty light. For this reason most artificial lighting is done with "bounce" flash. In bounce lighting the light source is aimed at a reflecting wall or white umbrella and that reflecting light lights the subject. The only problem with "bounce" light is the loss of an average of about two *f*-stops of light over direct usage.

Electronic flash has replaced the flash bulb in most common use. The principal advantage is that electronic flash is reusable. You can also use floodlights or lamps, but then in color photography you must use "tungsten" color film. Strobe light is daylight in color when used direct and takes on the cast of the reflecting surface when it is bounced. For this reason a white umbrella setup is especially useful

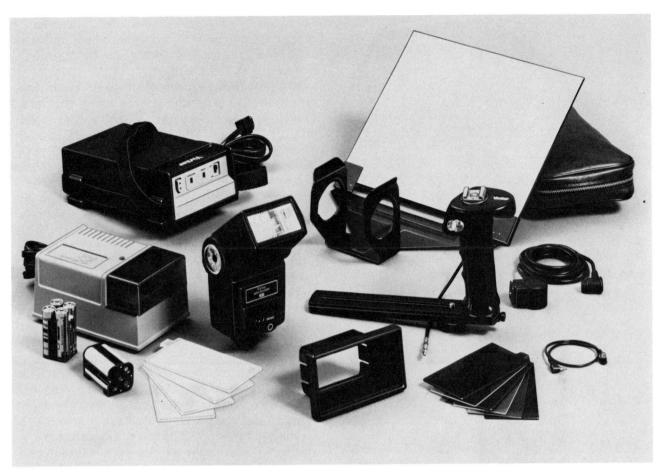

with color photography. The umbrella will keep the color of the light a clean white daylight. And though the white umbrella setup is not as portable or convenient, it is perhaps the most common professional portrait and fashion lighting setup in use today. The flash head is aimed into the umbrella, which is aimed toward the subject from a 45° angle a little high and to one side of the camera. This light most approximates soft afternoon daylight. Because the light is off the camera and to the side, an extension PC or "synch" cable must be used to attach the flash head to the "X" terminal of the camera.

The duration of an electronic flash is very short, usually 1/250 sec. to 1/2000 sec., and because it is the light from the flash that actually exposes the film, the effect is that of an extremely fast shutter speed. In order to synchronize the camera's shutter with the flash, the camera's shutter speed must be set at the proper synchronizing speed (usually 1/60 sec. or 1/125 sec.) or slower. As the effective shutter speed is so fast, it will freeze most action. This is an advantage with small children who have trouble sitting or posing. As long as the shut-

Portable electronic-flash units have become more and more sophisticated in recent years, and many manufacturers now offer accessories for use with their units. Shown here is one popular unit, and such accessories as a battery recharger, a bracket (for mounting the flash to the side of the camera), wide-angle and telephoto lenses, colored filters, and even a reflector panel for simulating the soft light of bounced flash.

ter speed does not exceed the synch speed, it will have no effect on the flash exposure. If, however, one is mixing flash with daylight intentionally, then the camera shutter speed will have an effect on the natural-light exposure. Flash lighting also has the advantage of being "cool"; there is no heat build-up to make the subject uncomfortable. The main disadvantage is that the photographer cannot see the light. For this reason experience in gauging different light situations is especially important.

Because flash exposure is so quick, most built-in exposure meters will not measure it. With most large studio flash units a flash me-

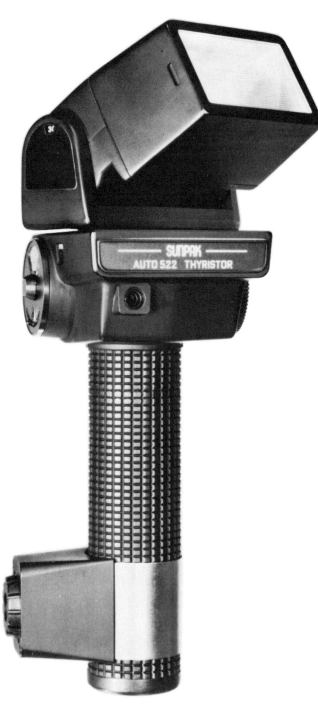

This sophisticated and powerful flash unit has a very fast recycling time and a head that tilts in almost any direction while the automatic exposure sensor points in the direction of the camera.

ter is used to determine exposure. The meter is connected by the PC cord to the flash and used as an incident meter—facing the light from the position of the subject.

Most modern portable flash units incorporate an automatic exposure system using thyristors. The unit is usually attached to the "hot shoe" atop the camera. There is a sensor cell usually attached to the base of the unit which always faces forward to the subject, even when bounce lighting is used. The unit is set according to the camera aperture desired, and the flash cuts off when the sensor determines that adequate light for that *f*-stop has been reached.

The least expensive portable flash units often do not work automatically when the flash head is turned for bounce lighting. In the better units the sensor always faces forward even when the head is rotated. Or the sensor may be a separate unit so that it will still face forward, reading the reflecting flash light off the subject whether the head is turned or is on an extension cord away from the camera. The completely automatic flash units are more expensive but much easier to use. Usually when you pay more for a portable flash you have the capability of using it "bounce" on automatic and have more light output than a less expensive unit. This means that you can use a smaller *f*-stop if you desire. More expensive units also often have a faster recycling time, the time it takes the flash condensor to build up power after a flash. Sometimes with a cheaper, slower unit, you will miss a photograph while you are waiting for the flash to build up to power. If you have a unit which functions automatically only direct, then you must estimate a light loss of an average of about two *f*-stops when you bounce. This will depend on the color and size of the room. A dark room will reflect less light than a light one, as will a larger room as opposed to a smaller one. Remember in color photography when bouncing light that you will pick up the color cast of the reflecting surface.

If you have a flash without automatic capability and no flash meter, then you must use the old system of guide numbers. Like ISO with film, the guide number is a mathematical formula for calculating the amount of light your particular unit gives off at a particular distance, depending on the film you are using. As light falls off evenly, it can be calculated according to flash-to-subject distance. As with ISO, the higher the guide number the more

light you have. As each flash unit has an inherent power or light capacity, a guide number can be established based on your particular unit. The guide number will be good for a particular film and a particular way of lighting. For instance, establish the guide number either for direct lighting or for white umbrella usage. As the reflecting surfaces vary in common bounce lighting, this method will not work well. So, for instance, if you intend to use the unit direct, take a color slide film of ISO 25/15° in an average setting and measure exactly ten feet from the subject to the flash. Then have the subject hold cards with each f-stop and half-stop marked on it and set the camera accordingly.

When the film returns from the laboratory, look at each slide over a light box and choose the best one. Key on the skin tones. If the best slide is at f/4, for example, then multiply the 4 times 10 and your guide number is 40 for direct flash. If you did the test with white umbrella bounce light, then the result will be correctly determined only for this setup. If the best slide is between f/4 and f/5.6, take 4.8 and multiply times 10, giving you 48. Using the guide number you divide the subject-to-flash distance into the number to determine your f-stop. For example, if the guide is 40 and the distance is 7 feet then the f-stop would be f/5.6. If the flash-to-subject distance is 10 feet then the correct setting would be f/4. The reason the guide is determined using slow slide film is because it has little exposure latitude and is processed mechanically, thereby allowing less margin for error.

Once you have the guide number for ISO 25/15° it is easy to establish the guide number for other films. Each time you double the ISO (for example, 25–50 or 50–100 or 100–200), you gain one f-stop of light. So going from ISO 25/15° film at f/4 to ISO 400/27° film (in the same situation) would be an increase of four f-stops of light: 25–50–100–200–400 or f/4–f/5.6–f/8–f/11–f/16. So if your guide number is 40 for ISO 25/15° it will be 160 for ISO 400/27°. This method can be very useful.

Synchro-sunlight
Sometimes in natural-light photography it is necessary to add light "fill" to shadows for a more evenly lit and pleasant photograph. This can be done with portable flash, but it takes careful calculation. If you use the unit normally the resulting photograph will lose its natural-light look. So you must fill in with less than normal flash light. As the flash must be used at the synch speed (or slower) this will be your first factor. That speed will then determine your f-stop based on the natural light. If the speed is 1/60 sec. and the resulting f-stop is f/11 then you must fool your flash unit into exposing the subject about one f-stop less than f/11. In effect you would want the flash to light the subject at about f/16. This can be done by setting the unit on automatic at f/16.

If you have a manual unit and are using the guide number, then multiply the guide number times two and place the flash in relation to the subject accordingly.

Balancing natural light with flash is something that takes practice. Keep track of exactly what you do technically so that you can learn and improve on your results.

Composition

A good composition will be *dynamic* and *graphic*; it will capture the viewer's attention. Generally it should also have a certain simplicity, avoiding visual clutter and distraction. Most amateur photographs suffer from complicated backgrounds and too much detail. In portraiture the main subject is the person, and everything in the composition should work toward emphasizing this.

There are two main elements in good classical composition: balance and lines of direction. They apply to all forms of visual expression and are important to understand. You should imagine the 35mm frame as a rectangle charged with energy—visual energy. When empty it has a sense of mystery, but gradually as you add subject matter it becomes dynamic. In order to attract and hold viewers' attention the photograph must do two things simultaneously that are paradoxical: the image must convey a sense of balance, of peace and harmony, and yet also be dynamic and exciting. You want to create a photograph that is peaceful but at the same time charged with energy.

Balance

Balance involves the feeling of equilibrium. When a painting on a wall is crooked or the horizon line in a photograph is on an angle it disturbs our innate sense of balance. In photography and the visual arts we can develop this sense through practice so that our images convey harmony. To understand balance in visual composition, imagine visual weight to be like physical weight and the frame as a scale perfectly balanced in the middle when empty. Without knowing the reason, amateurs often place their subjects in the middle of the frame. If you put the subject on one side of the frame, then the sense of balance is disturbed;

there is too much visual weight on one side. As with physical weight, you need a counterbalance to make a good photograph.

The counterweight need not be another person. It can be any form that has a strong visual presence. Geometrical forms are always stronger than nongeometrical forms. When visual balance is attained (and it takes practice), then the frame does not "tip" one way or the other. It is much easier to learn and use balance if you use simple backgrounds and only a few elements. Once you have a sense of ordering balance you can become more complicated in your compositions.

When the photographs in this book are not centered, they are often balanced either side to side or corner to corner.

Lines of Direction

Lines of direction affect how the viewer's eyes move within the image. This movement is the dynamic element within the peaceful setting created by balance. Ideally, you want to keep the viewer's eye moving in a circular fashion within the image. The eyes follow the contours of forms and the angles at which they are set. Even in a peaceful portrait where the subject is not doing anything dramatic, the composition can create visual excitement through the lines of direction. Keep in mind, though, that you are taking a portrait, and do not allow the compositional elements to overwhelm your photograph, thereby distracting from the subject, which should be the main element.

The direction a subject is looking will create visual movement. A person on the left side of the frame looking to the right will create lines of direction moving to the right. Although in this situation the right side may be empty, making it appear that the balance is weighted

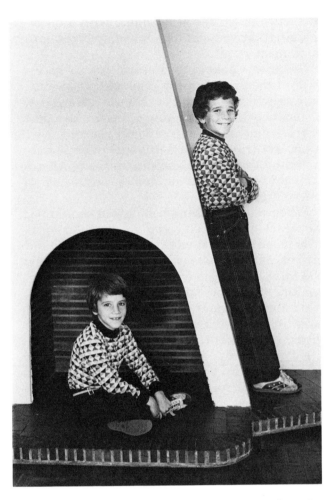

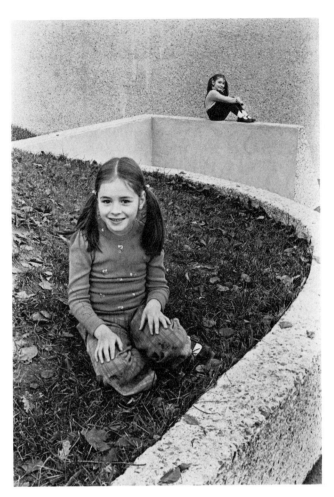

This photograph is a good example of a number of different compositional elements: visual balance, diagonal lines of direction, and subject-background contrast.

In this photograph already existing lines (the wall) were used to direct the viewer's eye from one of the subjects to the other. The photograph also has good corner-to-corner balance.

too heavily to the left, the throw of the subject's glance will fill the space, putting it into balance. The great American painter Edward Hopper often used this dramatic device. He would have a subject sitting on one side of the frame in a profile looking to the other side. It gave a sense of mystery to the scene and was a subtle but dynamic way to order the space. The sense of balance would be defeated, however, if you placed someone in profile near the edge of the frame looking out of that side of the frame. For this to work the subject must be "filling" the uncharged opposite side of the frame. It could also work with corner-to-corner balance when the glance takes a diagonal movement. In general, keep in mind that diagonals are the strongest visual movements within a rectangular frame.

Empty and uncharged space in the composi-

tion will make for boring images. The movement of the lines of direction should always fill the frame, even if there is little actual subject matter. This will take practice. If you spend some time examining your photographs, keeping these principles of good composition in mind, you'll find that it becomes easier to utilize them during your next portrait session.

Tonal Separation
In black-and-white photography you must consider tonal separation, or contrast. In color photography a brown and a green of the same tonal value will separate, but they do not in black and white. This merging of tone in black and white hurts the dynamic by flattening parts of the scene, rendering them two-dimen-

sional. It is disturbing to the viewer when the subject blends into the background. You will notice in the images in this book that attention has been paid to this separation in the interest of a more graphic image. A panchromatic viewing filter, often used by cinema camerapeople, is useful for seeing in advance how the film will record the separation. They are made for either black and white or color.

You can use depth-of-field techniques to create tonal separation. If the tones tend to blend, make your subject sharp and the background out of focus. The eyes always go to the sharp part of an image, thereby minimizing any similarity in tone. Be aware of this problem when you photograph: there may be a simple solution. For an indoor pose, for example, closing light drapes behind a person dressed in dark clothes can provide just the contrast you need.

Other Elements of Composition

Backgrounds generally should be simple and uncluttered. You can utilize elements of the background to create many different effects. Relationships in shape and color (or tone) can form links between subject and background. And you must be aware of problems caused by the background.

One factor to consider is the flattening effect of making a three-dimensional scene into a two-dimensional image. A vertical object that is behind a person, such as a tree or lamp, may appear in your photo to be growing out of the person's head. A slight change in the person's stance or a different camera angle will correct this. On the other hand, with a bit of imagination you can use this effect to create a striking portrait.

Be on the lookout for natural frames occurring in the environment. You can place your subject within a frame of this sort—a window or doorway, for example—or you can use part of the frame as a compositional element. Using a natural frame, with foreground objects surrounding the subject and drawing attention to it, is a very effective method of controlling lines of direction.

When photographing people you should be very careful how you "crop" or cut their forms. It is usually very unattractive to cut off hands or feet. Either photograph in close or preserve the total form. It is often more interesting to use the environment than to take the clichéd head-and-shoulders portrait time after time. And this will give you more compositional ideas. Experiment and learn.

Composition is much easier to practice if you carefully set up your images. Later you will be able to work more quickly, applying these elements of good composition in your candid photography. Most of the photographs in this book were carefully set up. It is easy to be sloppy in your compositions when you work too quickly. Even after you take the portrait, think of two or three variations and try them. You will learn more from experimenting than from always taking conventional images. Try to copy some of the images in this book. Try to improve on them. Keep track of what you do. Only through practice will you improve and make creative and exciting photographs.

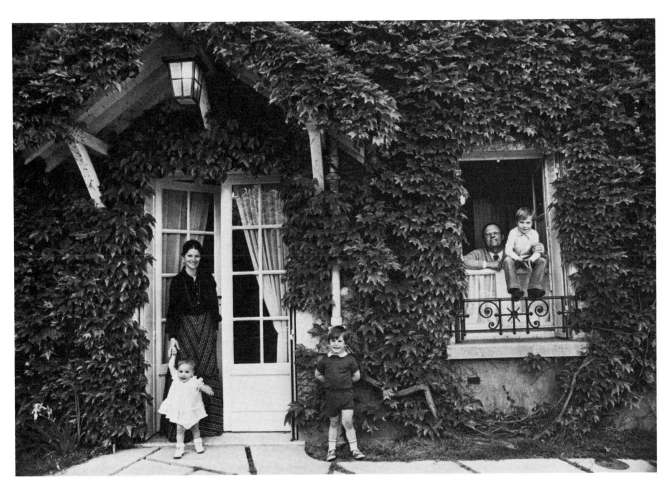

Positioning your subject (or subjects) inside of exist-
ing frames (windows, doorways, tree branches, etc.)
is a strong and easy compositional technique.

Working with People

Cameras often intimidate people, and it is important for you as the photographer to put the subject at ease. Not only will this make the person more comfortable, but it will also result in a more flattering portrait. How this rapport is accomplished is a matter of your own personal style. As always, practice helps.

A subject will not relax if he or she senses that the photographer is nervous or ill at ease. Therefore you should always conceal these feelings and cultivate the equivalent of a doctor's "bedside manner."

It is, of course, difficult for you to relax if you are unsure of the technical procedures. No one likes to "hold still and smile." So the technical preparation should ideally be done before the instant of taking the picture. The act should appear effortless to the subject.

The photographer should learn to be patient, having confidence that eventually a good photograph will result. The popular idea that the taking of many pictures will necessarily result in a "good one," is a fallacy. But one should alway take extra images, knowing that people tend to relax later into the session. Usually the first images will not be the best ones.

The subject will often imagine how he or she is doing in front of the camera, and you will hear remarks such as "Oh, I'm sorry, I blinked." Try to discourage the subject from thinking along on the quality of the images. This will only make for nervousness and impatience. The photographer should convey (and believe) that individual "bad" photographs are nothing important because eventually at least one good image will manifest. Sometimes it happens faster and other times it takes longer, but you must have confidence in eventually obtaining a good image. And, most important, you must convey that confidence to the subject.

This is crucial when photographing adults, who are especially sensitive to how they will look in the image. Many people are convinced, usually from prior unpleasant experiences, that they will photograph badly. Some people are naturally more photogenic than others, but everyone can be photographed well if a good rapport is established and soft lighting is used. Soft light and a relaxed subject will take you much of the way to a good result.

Photographing Adults

When photographing adults it is often good if you can carry on a calming conversation so as to distract the subject from worrying about the camera or the resulting image. Otherwise it is very difficult for the subject to relax in stony silence in front of the camera. And whenever possible, do not force the subject to "hold still" for more than an instant. You can have the subject stay in one place because of the composition, but do not have the face focused and set until the moment you are ready. If a subject sees that you will not require "holding" a look, he or she will be much more amenable to continuing the session.

Most adults have had bad experiences with being photographed. Either the session was uncomfortable or the resulting image was unflattering, or both. So the photographer is forced to overcome this prejudice and quietly convey to the subject that "this time" will be better. And the photographer will make matters easier by not photographing the subject when he or she is not looking especially good, because of fatigue or special nervousness. When possible, choose a time in the day or week when the subject will be more relaxed.

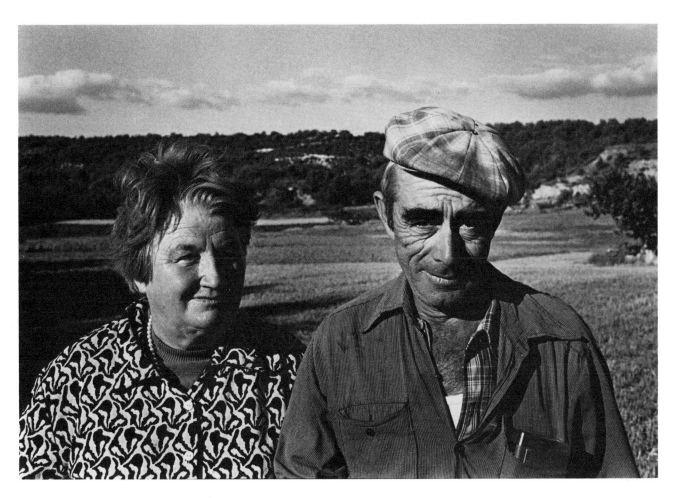

Photographing Children

Children at a certain age sometimes like to be photographed, but normally they consider it a great bore. So even if you have a particular image in mind it is usually preferable to begin photographing a child doing something he or she suggests or is interested in. This will create a congenial mood and make the session fun for the child. Children usually like to be active, and so "action" photographs are natural. Never badger a child about unwillingness to be photographed. If a child refuses then do not force the issues. Rather, be content to do candid images when the child is distracted or unaware. It may not be what you wanted, but the end result will probably be better than forcing the child, causing sour expressions and sore feelings. If you establish a precedent with a painless experience, then the next time will be much easier. All it takes is one bad experience to ruin any future sessions. So never give the impression of forcing yourself on the subject even if underneath you are directing the experience and designing the image.

The most important thing to remember when working with people is to make them relax. Conveying that you have confidence in your photographic abilities will help the subjects have more confidence in their appearance and make them relax, for a more natural-looking photograph.

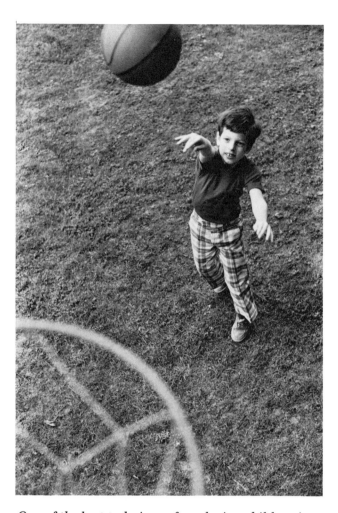

One of the best techniques for relaxing children in front of the camera is to take photographs of them doing things they like. Doing so makes picture taking a more enjoyable experience for both the child and the photographer, and usually also results in a more interesting image.

If the children are older, then quieter activities may be used. Sometimes a child plays a musical instrument or likes to read, for example. Soft window light is often pleasing in these situations. If there is no subject movement at all, you may want to use a tripod so that you can stop down your aperture where the lens is sharper.

When doing a series of portraits of a family, you can vary the emphasis on family members in the images by changing their positioning and size. In one image you might have the entire family relatively equal in size, and in another you might make the children bigger (closer) and the parents smaller (farther away). This makes for more interesting visual compositions and usually pleases everyone.

The best technique with children is occasionally asking them what they want to do. This is especially good at the beginning of a session. Even if their idea is not good from a photographic standpoint, it is probably better to follow that direction for a few images than to ignore it or disagree and put a damper on the rapport. Children like to be invited into the photographic decision making, provided the ideas look like fun. So start off with "fun" ideas and then go for the "serious" portrait. Creating the right first impression on the child is crucially important. If initially it appears that the session will be "work" then it will be very difficult to overcome the resulting mood and atmosphere. And—though it is easier said than done—do not lose your temper and your patience. Just believe that eventually you will get the good photograph you want. Be sympathetic to your subject and your subject will cooperate with you. A good portrait session should always be a collaboration.

Portrait
Workshop

Consider Depth of Field

The simplest way to make a well-balanced portrait of one person is with the subject framed in the center. Even though the person has dark skin and hair in this picture, there is tonal separation from the dark background because the person is in focus while the background is not. The natural light is soft and gently models the face.

Because the built-in exposure meter corrects for 18 percent medium gray, this person's face, if exposed automatically, would be too light. From the automatic reading the aperture was closed or "stopped down" about one *f*-stop using manual mode.

The lens was 90mm, a medium telephoto with shallow depth of field, and the aperture used was *f*/4 at 1/250 sec. A medium telephoto is a good lens for "head-and-shoulders" portraits with no perspective distortion. Because the lens allows the photographer to keep a good distance from the subject, all the facial features remain distortion free.

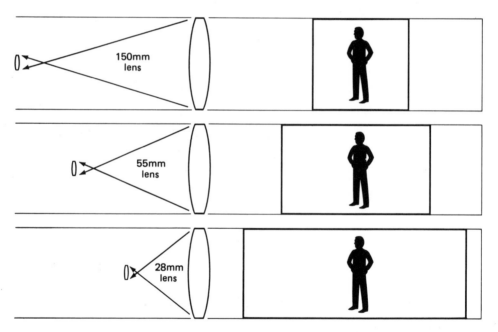

This diagram shows the different depths of field for lenses of different lengths. The vertical lines indicate the area in front and in back of the subject that is acceptably sharp. The longer the lens, the shorter the depth of field (at the same aperture and lens-to-subject distance).

Try Shooting a Profile

The composition in this photo is basic and simple, but the subject in profile makes it more interesting. This is a graphic image especially because the person is mostly in dark tones set off against a snowy white landscape. The background is out of focus, which directs the viewer's eyes to the subject. The eyes always go to the focused or sharp part of any image. The lens was 105mm and the aperture f/5.6; the shutter speed 1/125 sec.

This type of situation will often fool an automatic exposure reading because of the predominance of white in the frame. As the snow and sky are much brighter than the light on the subject's face, the meter would automatically "close down," thereby underexposing the subject. When the light of the total scene is different from the key light on the subject, you should move up close and take an exposure reading off the face. This type of situation underscores the importance of being able to override an automatic exposure and set the camera manually.

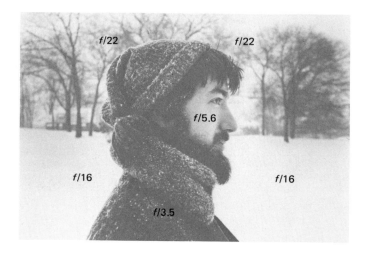

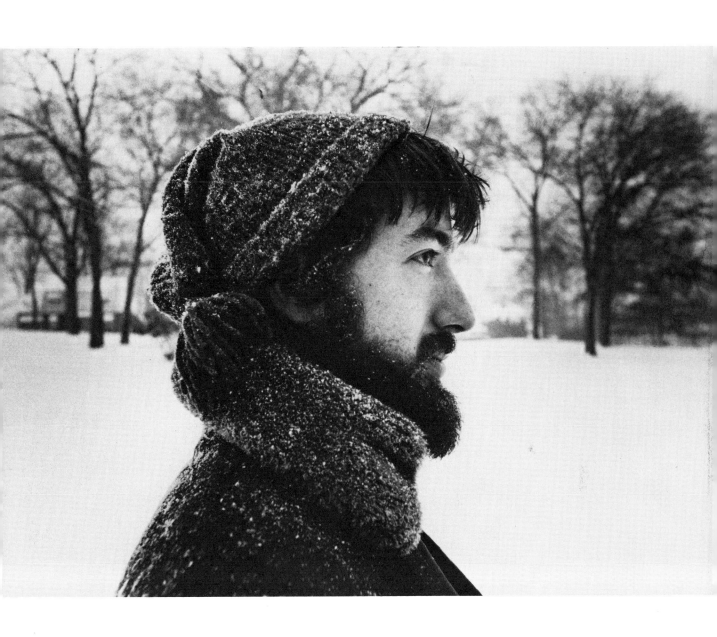

Judge the Exposure

Here the tonal situation is just the opposite of the preceding image. There is a predominance of dark tones. If the exposure were made automatically the subject would end up too light. The meter would "see" the scene as dark, and would call for more light. Because the subject is lit from the side window and is relatively small in the frame, the camera would make an overall reading that would sacrifice the main subject. Here you should take a close-up reading of the face and then open up one stop to compensate for the background. Also, 18 percent medium gray is one stop darker than a Caucasian face, so exposing a face as the meter normally dictates will render it too dark.

The light, though soft and pleasant, was of a low intensity, so a good tripod was used along with a shutter release. The central figure was balanced on one side by the window and on the other by the floor plant. The window was "burned in," or darkened, when the photograph was printed. The lens was a 28mm.

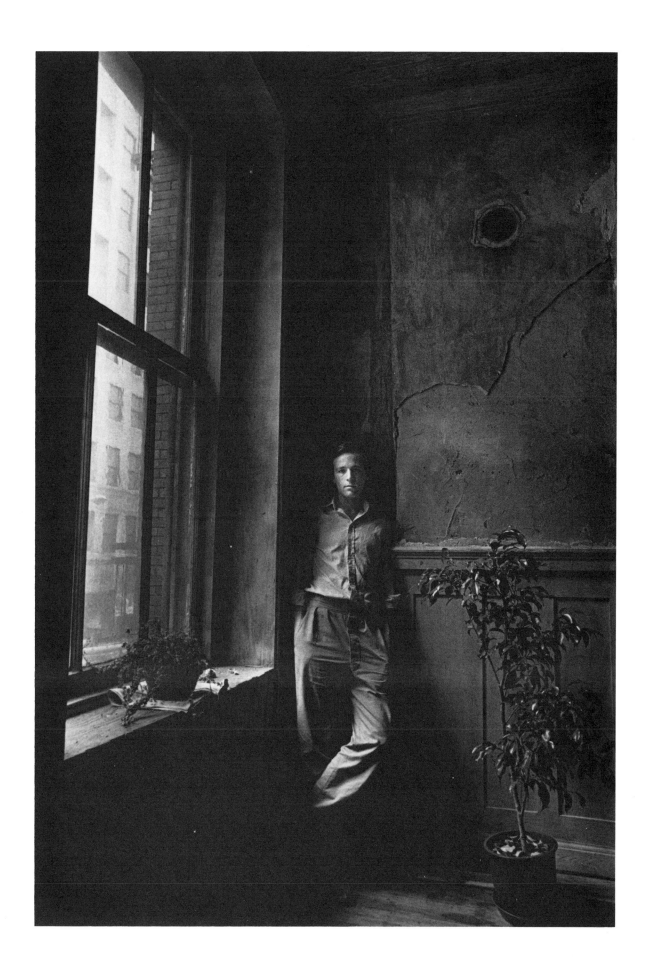

Shoot a Closeup

This closeup of a man's face is made interesting because of two elements: first, the contrast between the sharpness of the shirt and the softness of the face. The shutter speed was 1/30 sec. and the subject's face was in movement. This accounts for the slight blur. If the photographer did not want any blur in this situation then 1/250 sec. would have had to be used. Second, there is perspective distortion caused by using a normal 50mm lens in close to the face. The head is slightly too big and the nose, which is closest to the lens, is even larger. Slight perspective distortion is usually not flattering to a person but often makes for a more interesting portrait. Note that a compositional rule is broken: the subject's head is cut in the framing. The person was bald and sensitive to the fact, so that was the principal motivation for composing in this manner. The camera was hand-held and the light was from room lamps.

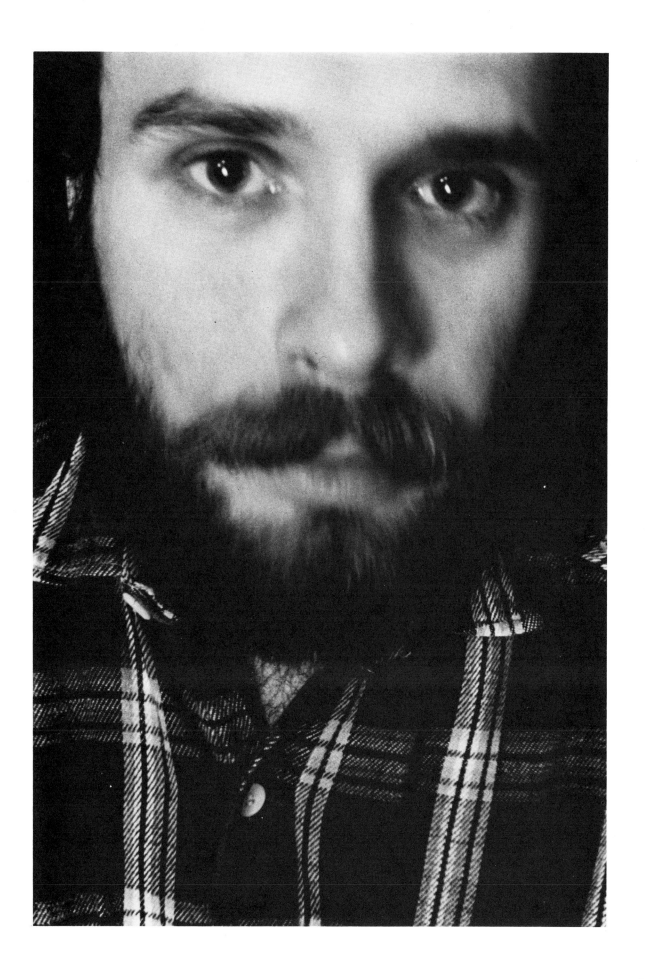

Frame the Subject Carefully

I photographed this little Polish girl in late afternoon natural light in a park in Paris. Though she is basically in the center of the frame she is leaning on an angle. The resulting movement is diagonal. A diagonal is always the strongest visual movement in a rectangular frame. A normal lens was used but at a large aperture, thereby causing shallow depth of field. If all the leaves had been in focus it would have been too distracting. As it is, the out-of-focus leaves form a pleasing pattern.

Notice how beautiful the light is on the face. It is soft and even, with no unpleasant shadows. The light source was the open sky without sun. The sweater has a simple but graphic pattern that photographs well in black and white.

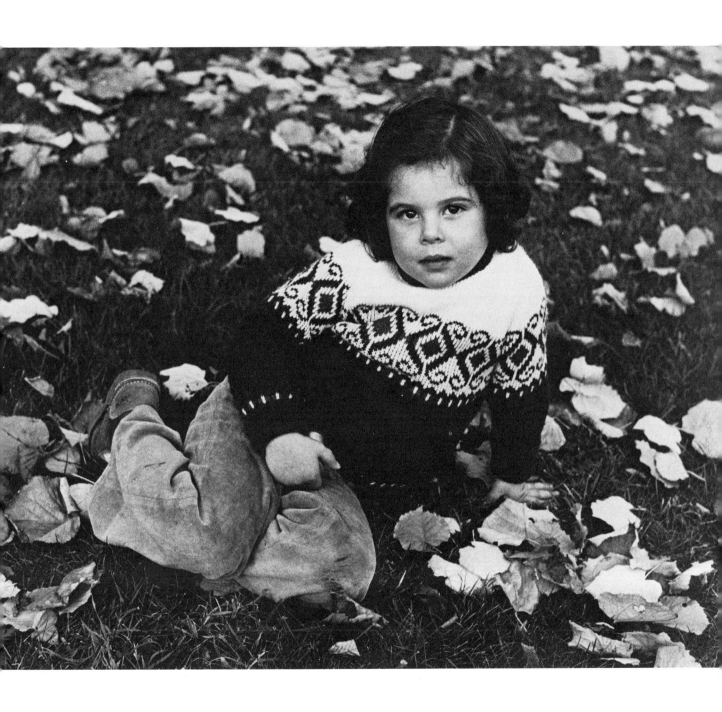

Sometimes moving back from the subject makes for a more interesting composition. Here the watery landscape serves an important function in mood and scale. The subject is in the middle of the frame and the pier leads you to him. The horizon line intersects his head, also drawing you to his face.

The technical difficulty here is exposure. The meter will normally be fooled by a background of all light tones. In such a situation, take a close-up reading off the subject's face and use that reading—which would, in effect, darken the scene one stop to compensate for the background. In normal situations, you "open up" one stop when using a facial reflected-light reading.

Some reflex metering systems have what is known as a spot metering capability, meaning the system measures only a spot in the center of the image. If you could not get close to the subject then a spot reading would be helpful. But if you had no spot meter you could take a reading off your hand, holding it at the same angle as the subject's face, and figure your exposure accordingly. This is a helpful technique when you need to take a facial reading and cannot get close to the subject. But this will work only if your skin tone is the same as the subject's. The exposure was 1/250 sec. at *f*/11. The light was overcast daylight.

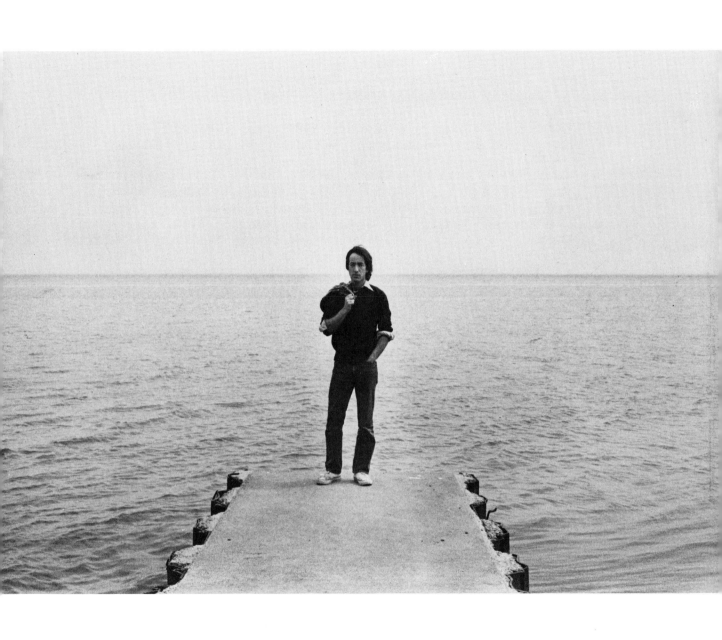

This is an action photograph. The little girl has just leaped off the concrete bench and the camera caught her in midair. The exposure was 1/500 sec. and the aperture *f*/1.4. Focusing would have been too difficult during the leap, so I prefocused the camera. This was done by standing the girl in front of the bench before the leap and focusing. The important thing when prefocusing is to place the subject at exactly the same distance from the lens as she will be during the exposure. Because action photography happens so quickly you can never be sure what the subject's expression was. Retake the image several times so that you will have a choice afterward.

Because the normal lens was wide open, the background is out of focus. This helps the image because otherwise the girl's dark dress would have blended with the grass. You will notice that by chance her right arm mimics the curve of the background walkway, giving a nice symmetry. And the other arm counters with a curve upward.

RECOMMENDED SHUTTER SPEEDS FOR MOVING SUBJECTS

Subject	Distance: Object to Camera	Direction of Motion	Focal Length of Lens				
			30 mm	75 mm	100 mm	150 mm	250 mm
People walking, children playing, slow-moving animals	7.6 m (25 ft.)	→ (parallel)	1/60	1/75	1/100	1/150	1/250
		↗ (diagonal)	1/40	1/50	1/75	1/100	1/150
		↓ (toward)	1/25	1/30	1/40	1/60	1/80
Horses galloping, bicycles racing, or automobiles at 48 km/hr (30 mph)	15.2 m (50 ft.)	→ (parallel)	1/180	1/275	1/360	1/550	1/900
		↗ (diagonal)	1/120	1/180	1/240	1/360	1/600
		↓ (toward)	1/60	1/90	1/120	1/180	1/300
Horses trotting, bicycles coasting, or children racing Automobiles, trains, 64 to 97 km/hr (40 to 60 mph)	7.6 m (25 ft.) 30.5 m (100 ft.)	→ (parallel)	1/200	1/300	1/400	1/600	1/1000
		↗ (diagonal)	1/120	1/180	1/240	1/450	1/750
		↓ (toward)	1/75	1/100	1/126	1/200	1/330
Fast athletic events	7.6 m (25 ft.)	→ (parallel)	1/300	1/425	1/550	1/850	1/1400
		↗ (diagonal)	1/200	1/300	1/400	1/600	1/1000
		↓ (toward)	1/100	1/150	1/200	1/300	1/480

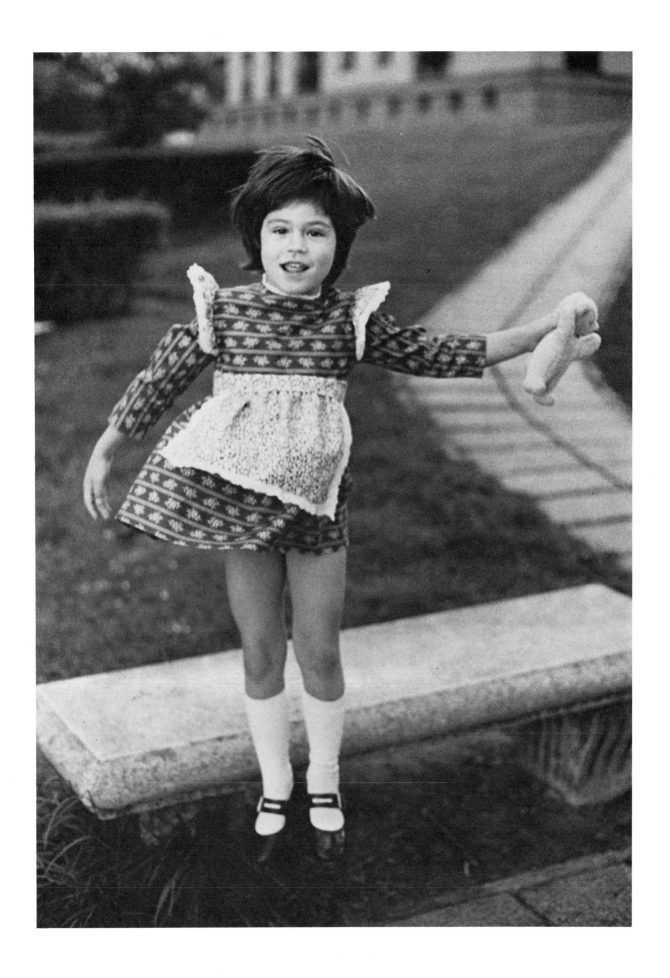

Shoot from High Above

This boy liked to play basketball, so he was very cooperative for this portrait. A ladder was used to position the camera and photographer above the net and over the backboard. The main problem in such action shots is to avoid being hit by the ball. The shutter speed was 1/500 sec. and several exposures were made. The light from the sky was soft and there was no sun. Though the boy is on the right side of the frame he is balanced by the diagonal movement of his arms to the left and by the ball and net on the left. Notice also the diagonal movement from the net to the boy's face.

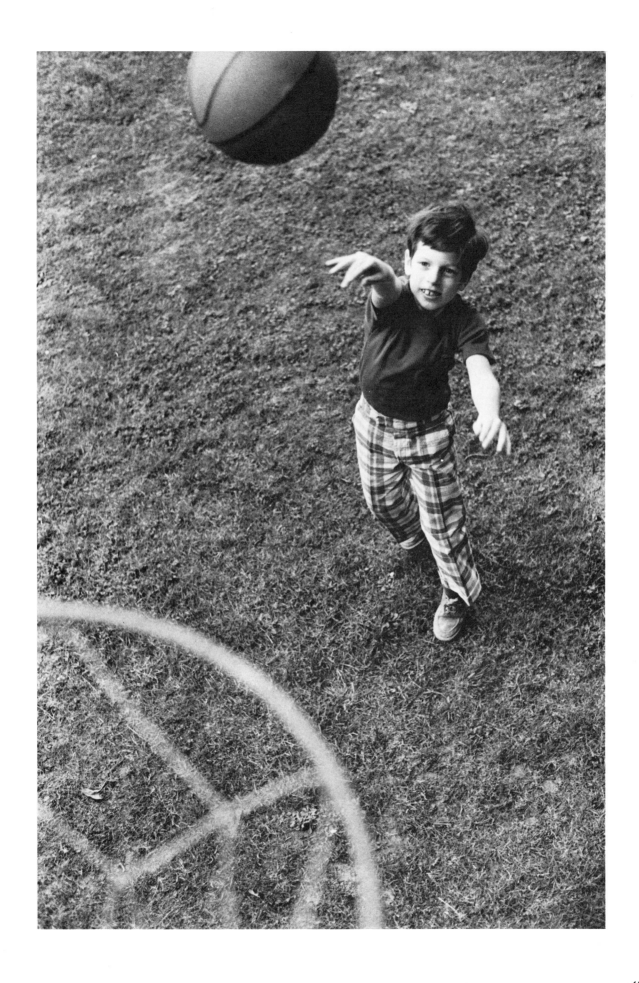

Experiment with Cropping

I used a different approach in this portrait of an older man. It is more a study of "age" than of a particular person. It would also work as part of a series of portraits of a person. The light was direct sun and the resulting contrast made it a difficult negative to print.

If you use a film of ISO 400/27° and are forced to photograph in bright sunlight you can reduce the contrast by setting your meter to ISO 200/24° (thereby overexposing the film) and developing it for about 35 percent less time. If you are giving the film to a professional laboratory that does custom developing you must tell them that the film was shot at ISO 200/24° so that they can adjust the developing time. This procedure will give you better negatives in contrasty light.

Use Natural Light

What makes this simple portrait of a baby in his father's hand interesting is the diagonal movement of the composition. Also, the light tones of the skin and clothes are set off graphically from the dark background. The light was natural light coming from a window. The shutter speed was 1/125 sec. and the aperture f/4.

The advantage of ISO 400/27° film for black and white is its versatility. It can be used outdoors in bright light or indoors in low-light situations. And the tonal range is excellent.

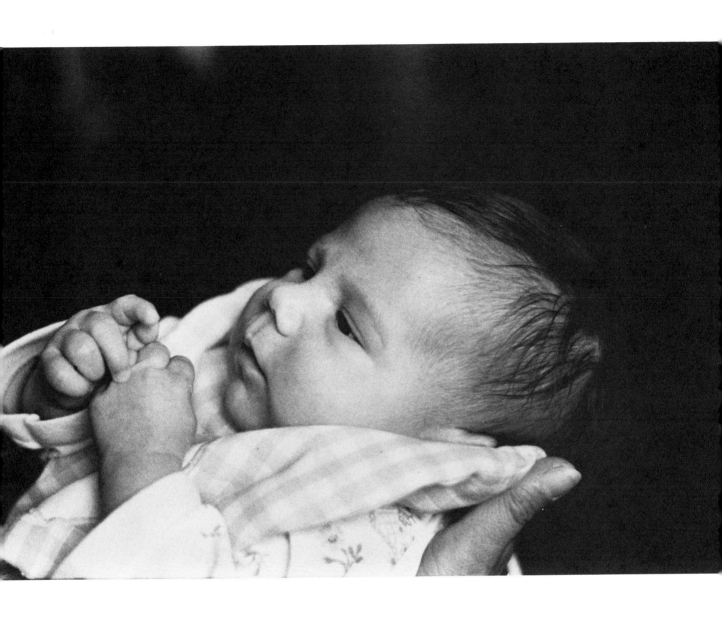

Try an Off-Center Composition

This girl, photographed on the terrace of an old stone house in the south of France, is slightly to the right of the frame. But she is balanced by the distant stone house, which is slightly to the left of center. The eerie stillness of the environment is reinforced by the formal, upright stance of the girl. The light was soft daylight and the depth of field was figured with a normal lens so that both the girl and the distant house would be sharp. Because the shutter speed was 1/30 sec. a tripod was used to eliminate camera shake.

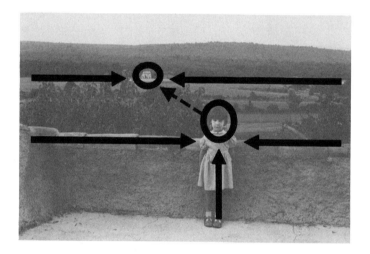

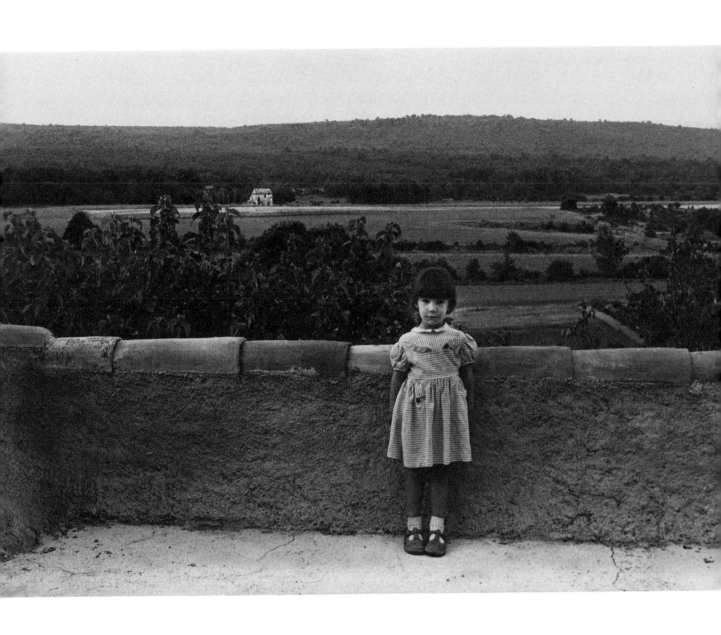

Photograph a Shy Child

This girl was leaping off the tree stump into the air. I prefocused the 135mm telephoto lens on the stump and instructed the girl to jump sidewards, so that the focus would not change. You can see that with a telephoto lens there is very little depth of field, especially when a faster shutter speed of 1/1000 sec. is used (to stop motion) and the lens is opened to a wide aperture. The aperture here was f/4. Because everything in front of and behind the girl and stump is out of focus there is a nice separation. Though the girl is off too much to the left she is balanced by the stump on the right. The composition is also more dynamic because of the diagonal movement from the stump to the girl.

Even children who hate to be photographed can usually be induced if action photographs are made. This is a good way to start a portrait session with a shy child.

The fastest shutter speed was used because the subject was moving parallel to the camera and magnified by the telephoto lens.

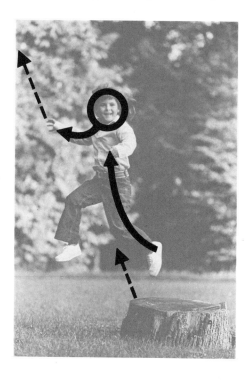

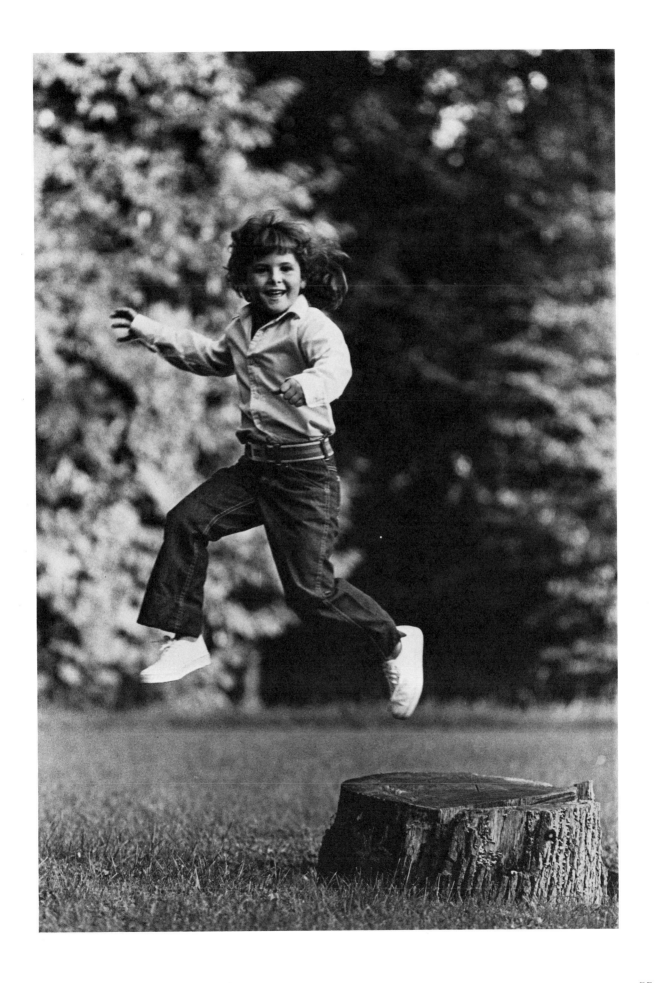

Use Hard Afternoon Light

This goat farmer and his wife were photographed in late afternoon sunlight in the south of France. The hard light emphasizes the textures of their weathered faces. This composition is simple and symmetrical, with one figure counterbalancing the other. A 50mm lens was used at *f*/8.

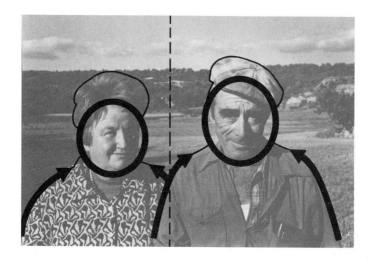

Use a Telephoto Lens for a Closeup

Acadia National Park in Maine was the setting for this summer twilight portrait. A 135mm telephoto lens was used on a tripod with a shutter speed of ¼ sec. The low light level necessitated a slow shutter speed and a tripod. A cable release was also used so as to avoid shaking the camera. Closeups of this type are often more successful with a telephoto lens because there is no perspective distortion.

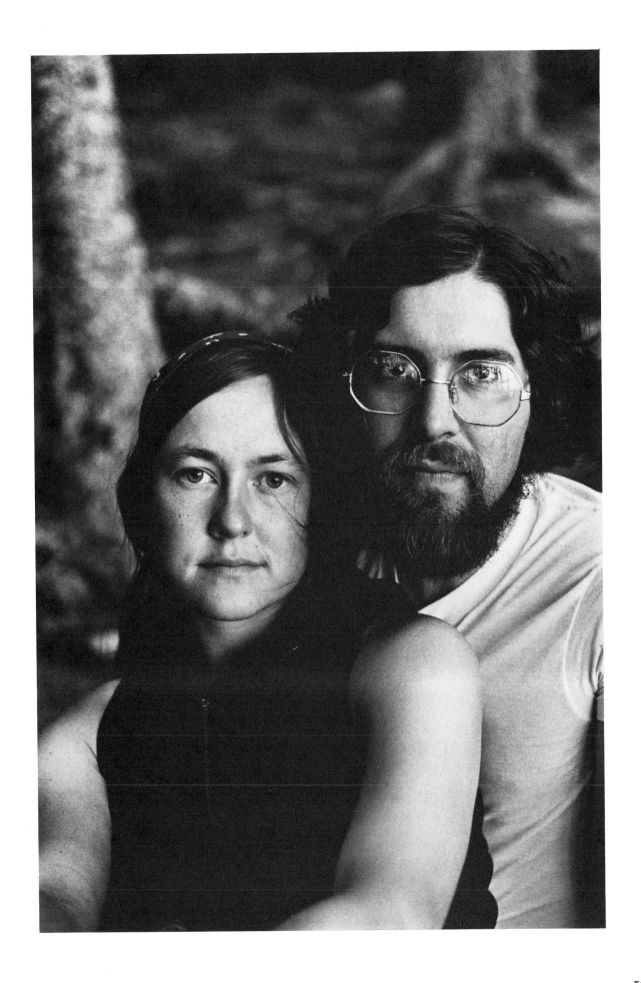

Use a Patterned Background

Though simply composed, this portrait is subtly dynamic because of two diagonal movements which are counterbalanced. This movement of the figures is set within a sea of patterns. The wallpaper, pillows, and woman's dress all contribute to the graphic impact. Pattern repetition is always a strong compositional element, especially in black-and-white photography. The light came from a lamp diffused through a translucent shade. A 50mm lens with the camera on a tripod was used.

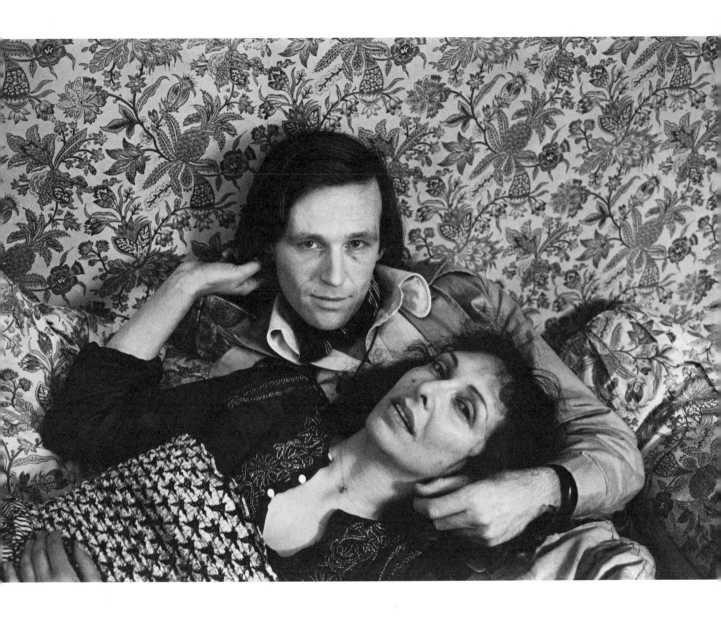

Soften the Focus

This portrait of my mother and sister was softened in the printing by interposing a dark nylon stocking between the enlarging lens and the paper. This is an old trick from Hollywood and early portrait photographers. The stocking should be stretched over a wire frame and kept in movement during the printing exposure. This is so the pattern of the stocking does not print. A dark stocking is used to minimize the loss of image contrast. If you do not do your own darkroom work, you can achieve a similar effect with any of a number of diffusion filters commonly available in camera stores.

The camera was on a tripod with a normal lens. The light came from the window on the right. The tilt of the heads inward makes the composition more interesting and intimate than if the heads had been straight.

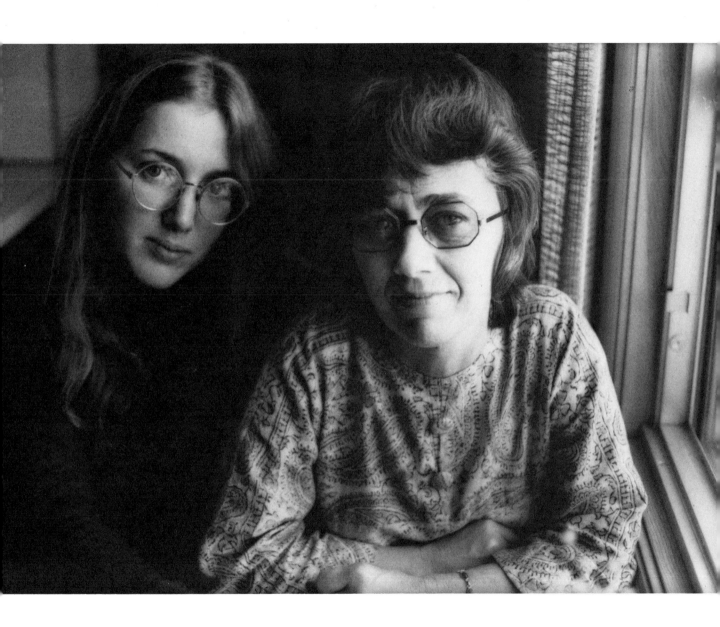

Use a Wide-Angle Lens

This homey portrait done in the couple's Toronto kitchen is simply composed. Though the couple is slightly to the left of the frame they are balanced by the white stove and vertical cactus plants on the right.

A close-up exposure reading ensures that the white walls and window light do not fool the meter into underexposing the negative. I took a reading off the faces and then set the lens at that reading to compensate for the background.

The 35mm slight wide-angle lens is ideal for interior portraits where you are interested in including the environment. The camera was handheld at 1/60 sec. and the aperture was wide open at f/2.

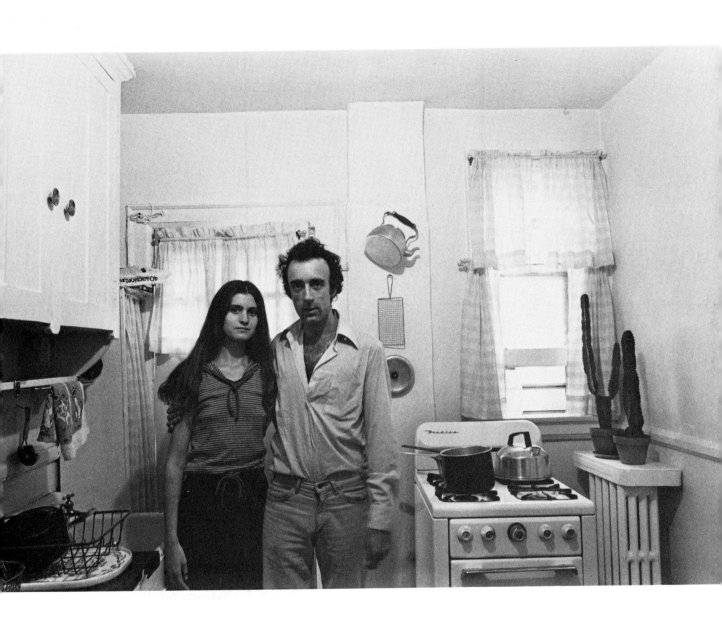

Focus On a Reflection in a Mirror

There are two factors to consider when using a mirror: one is focus and the other is not getting the camera in the photograph. When photographing a reflection in a mirror the actual focusing distance is the total distance from the camera to the mirror and from the mirror to the person. For purposes of depth-of-field calculation in this image, the actual people and their reflection needed to be in focus. So on the depth-of-field scale the boundaries would be the distance to the subject on one side and the distance from the camera to the mirror and from the mirror to the subject on the other. You can calculate your distances simply by focusing the lens carefully and checking the corresponding distance on the lens. For instance, if you focused on the children and got 8 feet and then on the reflection and got 12 feet, then on the depth-of-field scale you would want 8–12 feet in focus. You would set your lens accordingly, choosing the necessary aperture.

You will not include the camera in the image unless you can actually see it through the lens when you expose the photograph. Any slight angle will usually take you and the camera out of the frame.

In order to take a photograph in which both the subject and its reflection are sharp, you must first measure both distances—from camera to subject, and from camera to subject through the mirror—and then set your focus so both distances fall within the depth-of-field indicators on top of your lens.

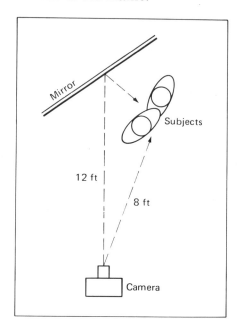

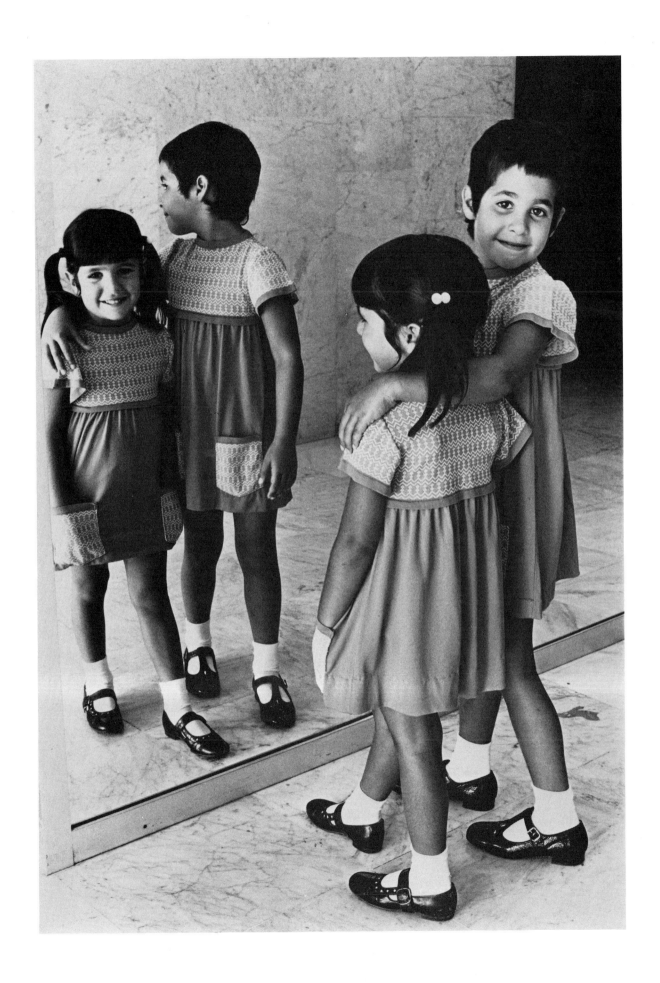

Use a Mirror and Bounce Flash

This portrait, done in Paris of two American children, used the mirror effectively. The depth of field was calculated by focusing on the reflection (this little girl was actually out of the frame, behind the camera) and then focusing on the baby. Those two distances became the boundaries for the focus setting on the depth-of-field scale on the lens.

The lighting came from an electronic flash bounced off the white wall on the left side of the room. The flash had to be placed an equal distance from each child in order to attain the same intensity of light, making one *f*-stop serve for both. Otherwise one of the children would have been lighter than the other.

The lens was a 28mm wide-angle, chosen especially for its inherent long depth-of-field capability.

This diagram shows the overall setup used for the facing photo. The mirror had to be angled correctly in order not to show the photographer, and for even exposure the flash had to be equidistant from each child.

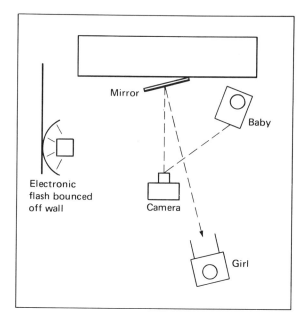

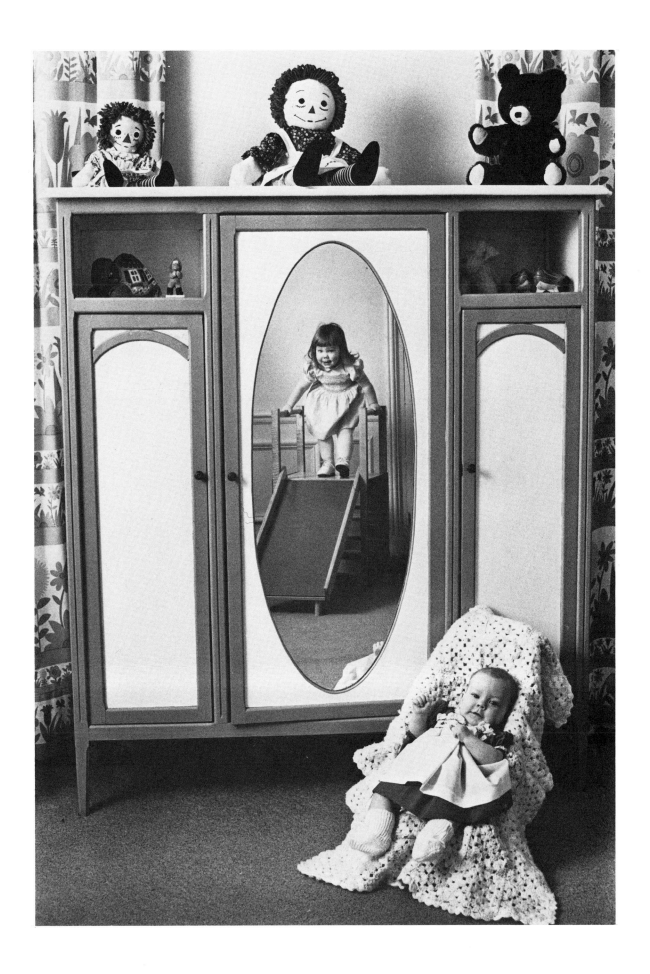

Include an Inner Frame

The crib in this photograph was a natural frame when photographed from above. In the printing, the background was darkened to eliminate distractions and accentuate the rectangular frame. This "inner frame" is made more dynamic by being photographed on a slight diagonal.

The lens was a 28mm wide-angle, chosen because of the need to frame the entire crib. The light was natural light coming from a large window.

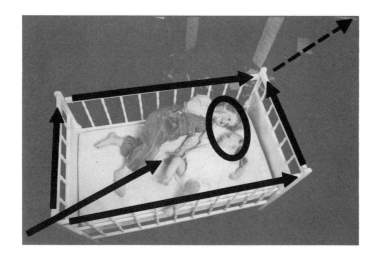

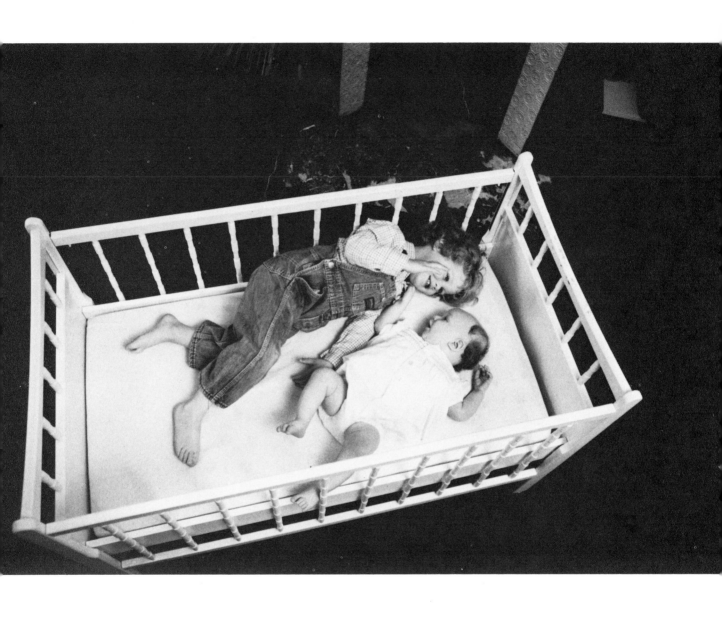

Use Perspective Distortion

In this photograph the older boy is much larger in the frame. The 28mm wide-angle lens exaggerates this perspective distortion.

The lighting is from a flash bounced into a white umbrella. The important focusing boundaries for figuring depth of field are the distances from the camera to each boy. Because it was impossible to have them both in perfect focus the focus was weighted toward the boy closer to the camera. Notice how soft this use of flash is.

This diagram shows the placement of the flash used to light the closer boy and bring the indoor light level closer to the light level outside of the window.

Arrange a Corner-to-Corner Composition

This photograph was taken from the top of the house. The boy was sitting on the second-floor balcony while his sister and their white cat were on the ground.

The composition uses corner-to-corner balance and is aided by the double curve. The white balcony railing and white cat also aid in attracting the viewer's eyes.

A normal lens and a small *f*-stop (*f*/11) were used in order to attain greater depth of field. The focusing boundaries were from the camera to the boy and to the girl. The shutter speed was 1/60 sec. and the light was late afternoon daylight.

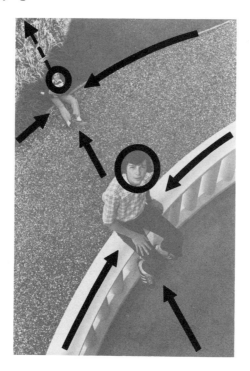

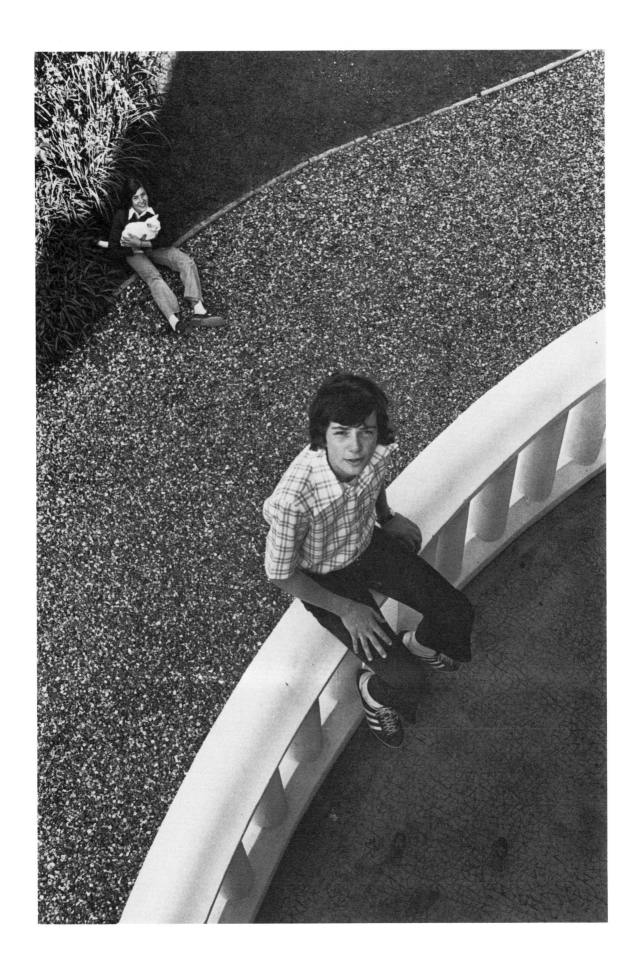

Take Advantage of a Curving Line

Sometimes the backgrounds available are not especially aesthetic. In this Paris suburb everything around was concrete. By using, however, the line of the wall I was able to create curving lines of direction that lead the viewer's eyes from one girl to the other. A 28mm wide-angle lens was used because of the inherent deep depth of field, especially when stopped down to a small aperture, in this case *f*/16. Because of the light loss from the aperture, a slow shutter speed and a tripod were used. Notice the slight perspective distortion in the foreground girl caused by the wide-angle lens.

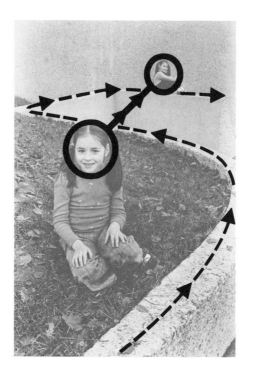

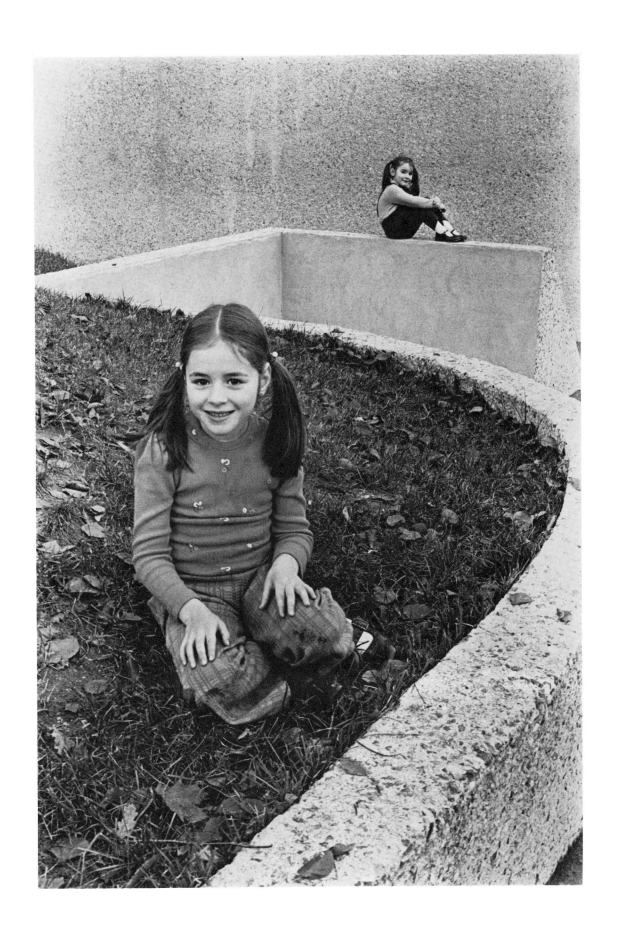

Shoot One Subject Out of Focus

This is a variation on corner-to-corner balance where one subject is in focus and the other is not. In this case not only is the depth of field shallow, but also the background subject is moving. The resulting blur adds to the visual dynamic. The shutter speed was 1/60 sec.

Though the tones of the girls' dresses are practically the same as the background, the strong sunlight coming from behind backlights the subjects, causing a pleasing separation.

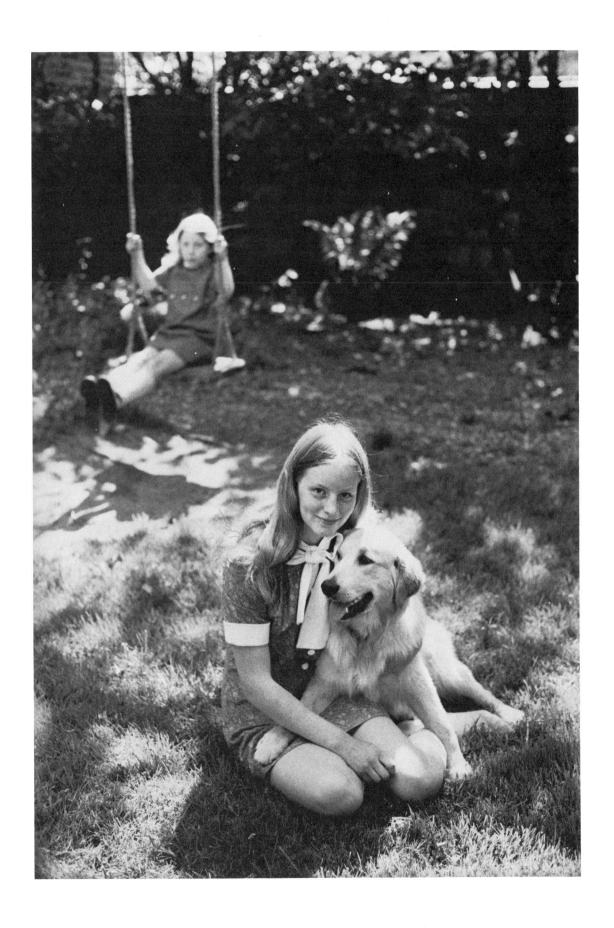

Catch Two Children in Midair

A photograph such as this one must be rehearsed. The two boys are leaping in midair. The problem is to get them in midair at exactly the same moment and at the same focusing distance to the camera. The image was planned by having one boy at either side of the frame running toward the other (parallel to the film plane) and leaping into midair just after they passed one another. One boy had to be slightly closer to the camera than the other so that they would not collide. The focus was preset by having the boys stand approximately where they would eventually jump and focusing on the nearer boy. This is because there is always more depth of field behind the focused point than in front of it.

The dark outfits cause the separation from the light foggy background. A shutter speed of 1/500 sec. was used to stop the action.

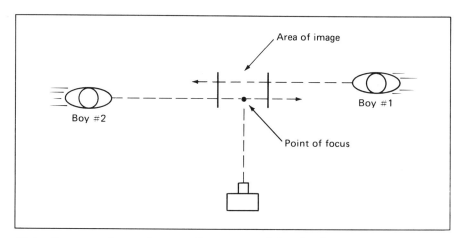

This diagram shows the overall setup used for the facing photo.

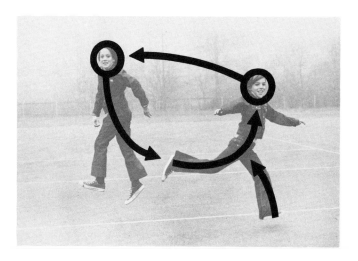

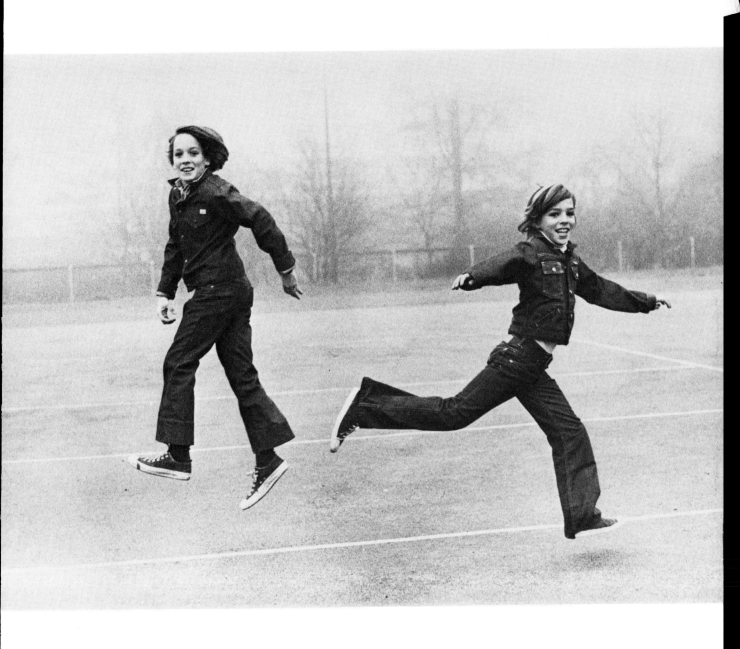

Focusing on a person moving toward the camera is more difficult than any other kind of focusing. Sometimes you can prefocus, but this was impossible here. It was made easier by using a 28mm wide-angle lens with all its inherent depth of field. Though using such a lens caused perspective distortion in the girl's legs (because they are closer to the camera), it is not annoying. The girl is also made more dynamic because the movement is on a diagonal. The shutter speed was 1/500 sec. to stop the movement. The composition is a combination of side-to-side and cor-ner-to-corner balance. The light shirt of the girl on the swing brings about good separation from the background and makes for a more graphic image.

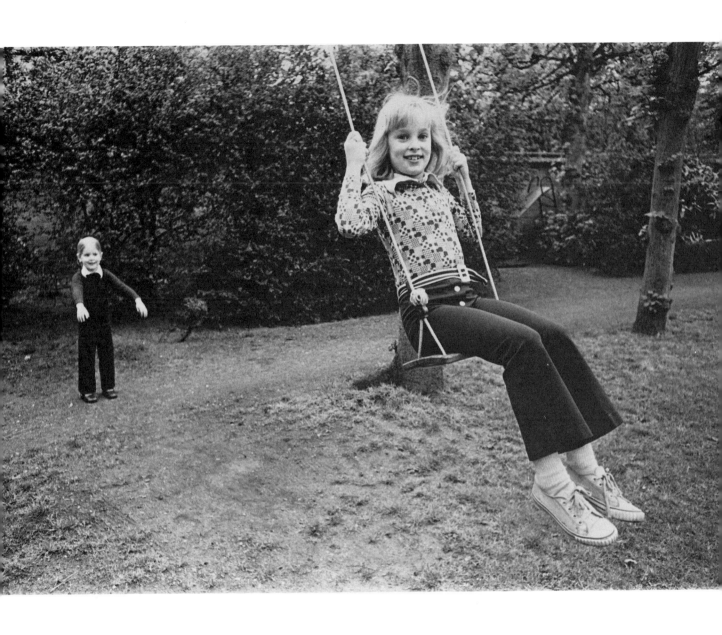

Capture the Delight in a Game

These English children liked to roller-skate. A 135mm telephoto lens was used to photograph them in action. They were shown an imaginary line to skate on across the scene. In this way the camera could be prefocused, since I knew in advance exactly what distance the subjects would be. Though the boy's dark sweater normally would blend into the dark background, the telephoto's shallow depth of field brings about separation through contrast in focus.

Because of the magnified motion caused by the telephoto, a fast shutter speed of 1/1000 sec. was necessary. The extra empty space on the left is "filled" by the subjects moving toward it.

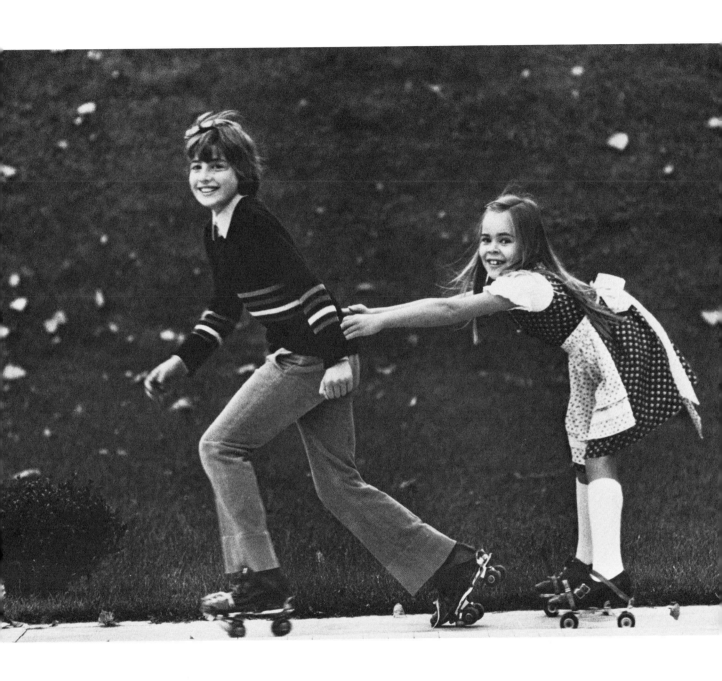

Steal a Candid Study

It was Saturday morning in Paris and this American father was reading the newspaper. The little boy was playing near the terrace with a model car. The 28mm wide-angle lens exaggerates the scale and makes the boy appear bigger than he is. This candid approach is easier on small children, who usually are impatient with "set-up" portraits. The light was soft daylight. The man is intentionally slightly out of focus to keep the emphasis on the boy.

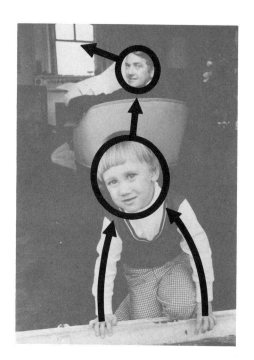

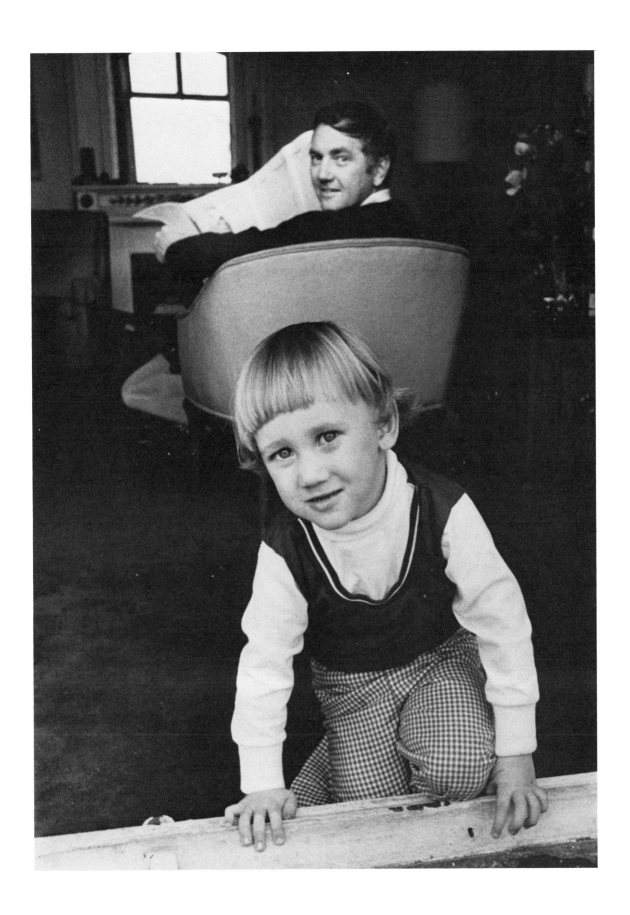

Take a Self-Portrait

For this portrait of my father and myself I used a self-timer and the camera on a tripod. The 35mm lens, set at $f/8$, was prefocused on my father and composed so as to allow space for me in the image. I had 10 seconds to enter the picture before the shutter fired. The brick not only introduces a simple and uncluttered background but also gives a nice texture. My current camera does not have a built-in timer, and so a separate accessory timer, which screws into the shutter button, was used. Whenever possible I try to photograph between $f/5.6$ and $f/11$ because any lens is always sharpest in that range.

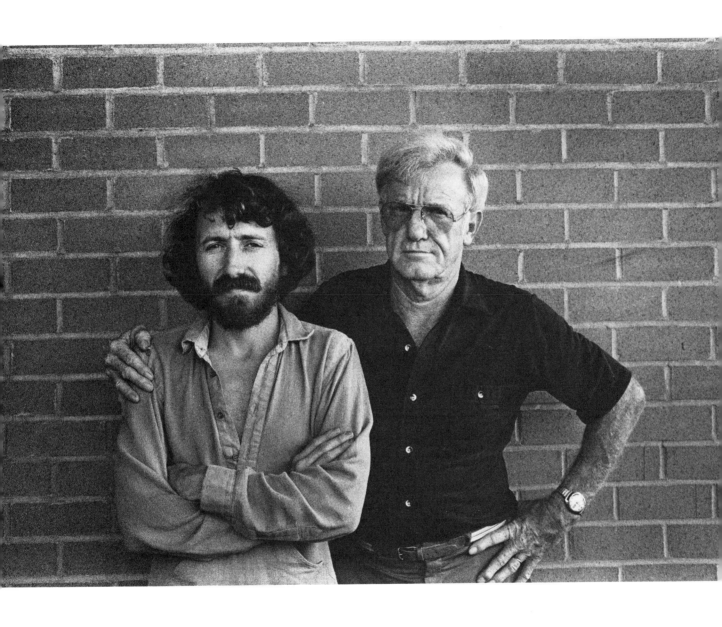

Photographed in the suburbs of Paris, this American couple was lit by white umbrella flash. The camera was on a tripod and the flash exposure dictated the *f*-stop. By varying the shutter speed (slower than the synchronizing speed), the background natural light was regulated to one *f*-stop less than the flash exposure. The change in shutter speed affects the natural-light exposure but is irrelevant to the flash exposure. After determining the flash exposure you can adjust the background light level by lowering the shutter speed. The resulting slow shutter speed (in this case ¼ sec.) necessitated the use of a tripod. The house lights were turned on for an added graphic touch. The wide aperture of *f*/4 made for shallow depth of field. Though the focus was on the people, the depth-of-field preview button allowed the photographer to visualize exactly what the differences in focus would look like. The preview button is a handy tool for determining how things out of focus will look; sometimes they can be distracting.

This diagram shows the placement of the flash used to highlight the couple in the facing photo.

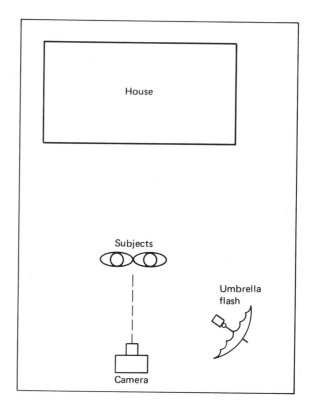

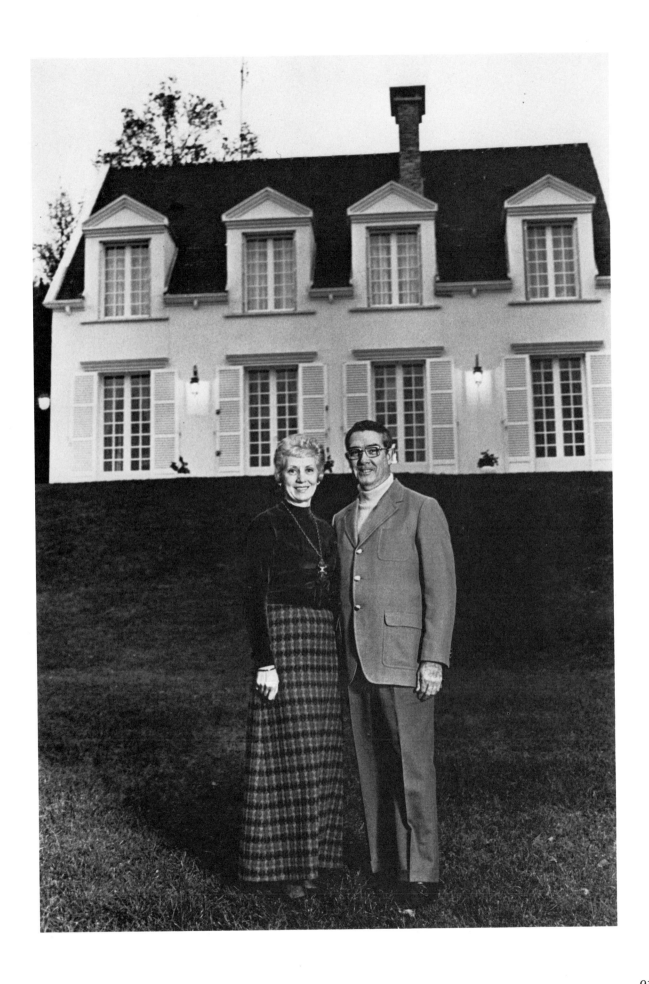

Incorporate a Room's Feature

The unused fireplace in this apartment proved to be the best background in this portrait of two brothers. By dressing them in matching shirts and posing them in relation to the oval of the fireplace and the diagonal side line, a pleasant composition was attained in an otherwise uninteresting setting. Large facing windows made for soft and even natural light. The pattern of the shirts also mixed nicely with the brick pattern. In general I always try to use simple backgrounds so as not to distract from the subject.

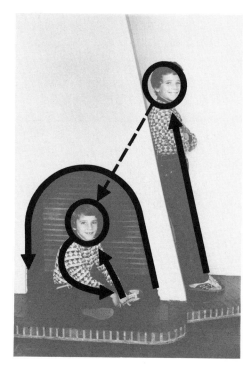

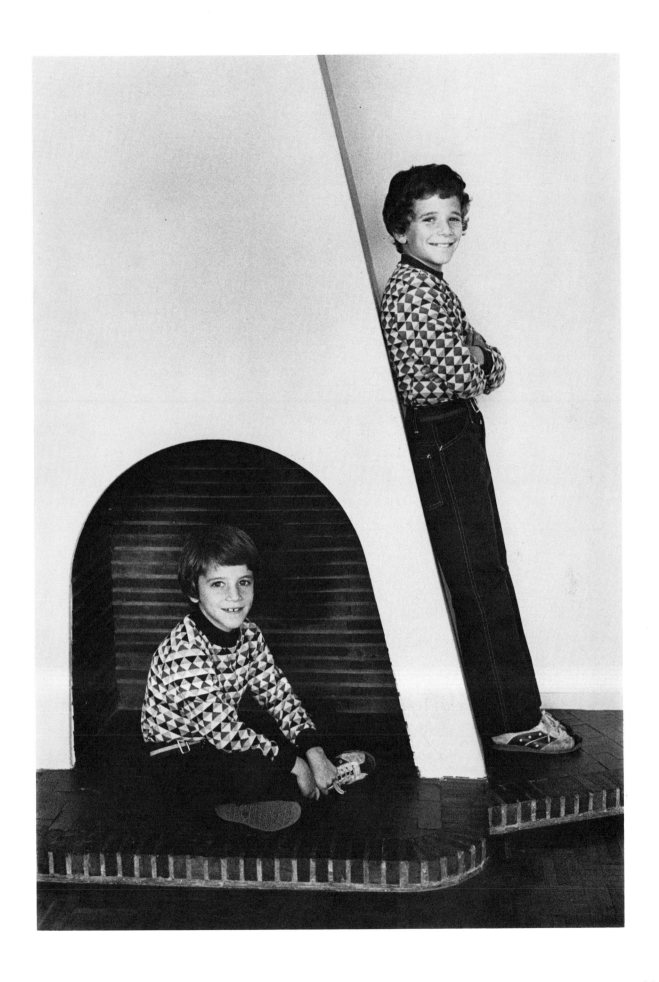

Use a Self-Timer

This self-portrait with a friend was accomplished using the camera on a tripod with a self-timer. The figures, standing on a wooden float on a pond in New Hampshire, were composed in such a way that the two floats created a subtle diagonal movement. The white floats also lighten up an otherwise dark background. White must always be carefully used because the eyes are always drawn to light areas. It can easily be distracting if used indiscriminately.

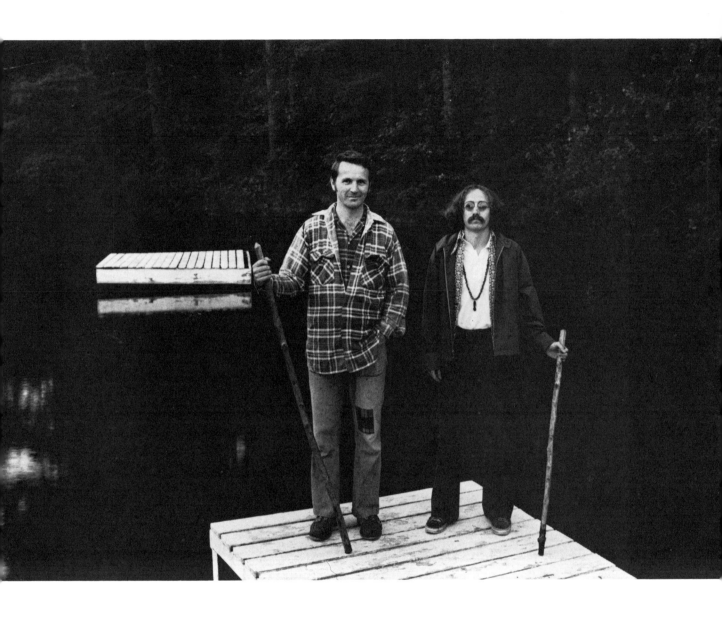

Vary the Scale

This father and daughter, photographed in the south of France, are standing on large rocks in a quarry. The scale of the rocks in relation to the figures makes this portrait interesting. The exposure on the 28mm lens was 1/125 sec at f/11. The depth of field was checked with the depth-of-field preview button. Variations in scale often make for more interesting compositions. Because of the positions of the figures and the rocks the lines of direction keep the viewer's eyes circling in the center.

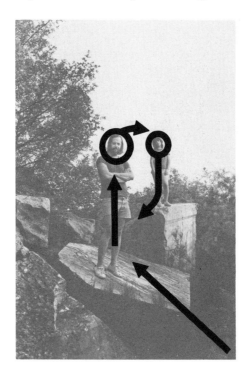

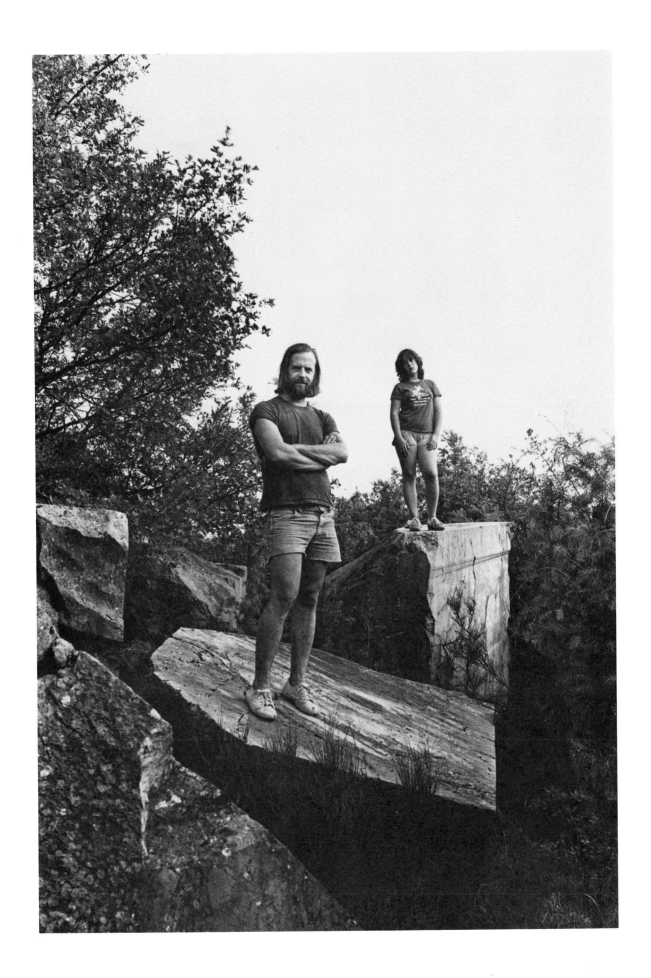

Frame the Subjects in a Mirror

These three children are reflected in a mirror. The children were standing behind and to the left of the camera. The focus was on the reflection of the children. Because the light from the white umbrella unit was not intense enough to use a small *f*-stop, the depth of field was shallow. Consequently the children reflected are sharp but the wall and frame of the mirror are not. This variation in focus actually helps lead the eye into the frame of the mirror and onto the subjects.

The umbrella flash was directed onto the subjects and not onto the mirror. Some "spill" light was used, however, to illuminate the wall around the mirror. The positioning of the figures causes a circular movement within the circular mirror frame.

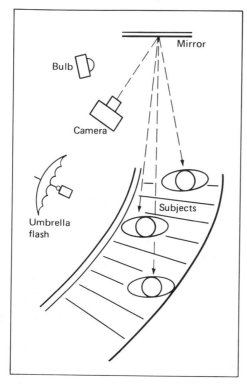

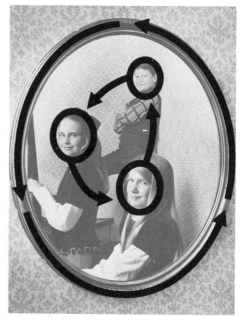

This diagram shows the placement of the umbrella flash used to light the subjects. Some "spill" light from the flash also illuminated the mirror.

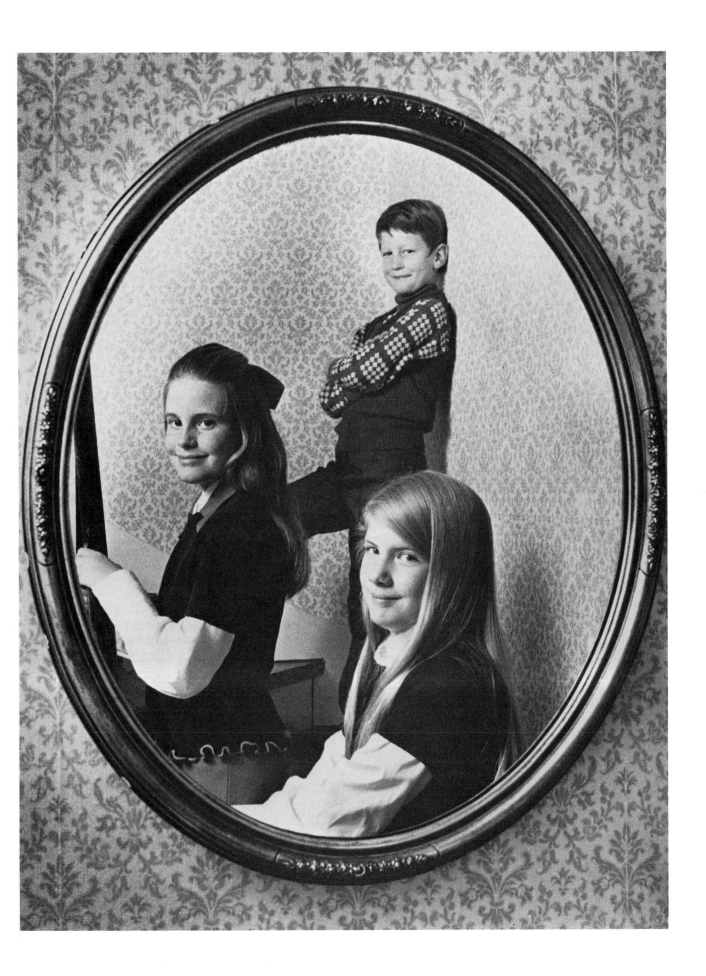

Stagger Subjects to Vary the Composition

Backgrounds often provide the key to portrait compositions. On portrait assignments my first task was usually to choose my backgrounds. Spiraling staircases are a common feature in French houses. This American family, living outside Paris, were posed in such a manner to use the strong lines of the banister. In this way I could lead the viewer's eyes from one child to the other. Architecture always influences the lines of direction. The wallpaper provided a pleasant repetitive background. A flash was bounced against a white wall in front of the children for the soft, even light. A 28mm lens framed the scene.

Here a flash bounced off a white wall provided soft, even lighting for the children on the stairway.

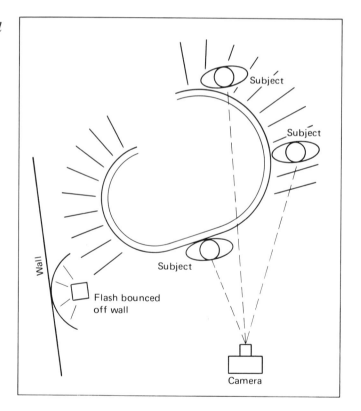

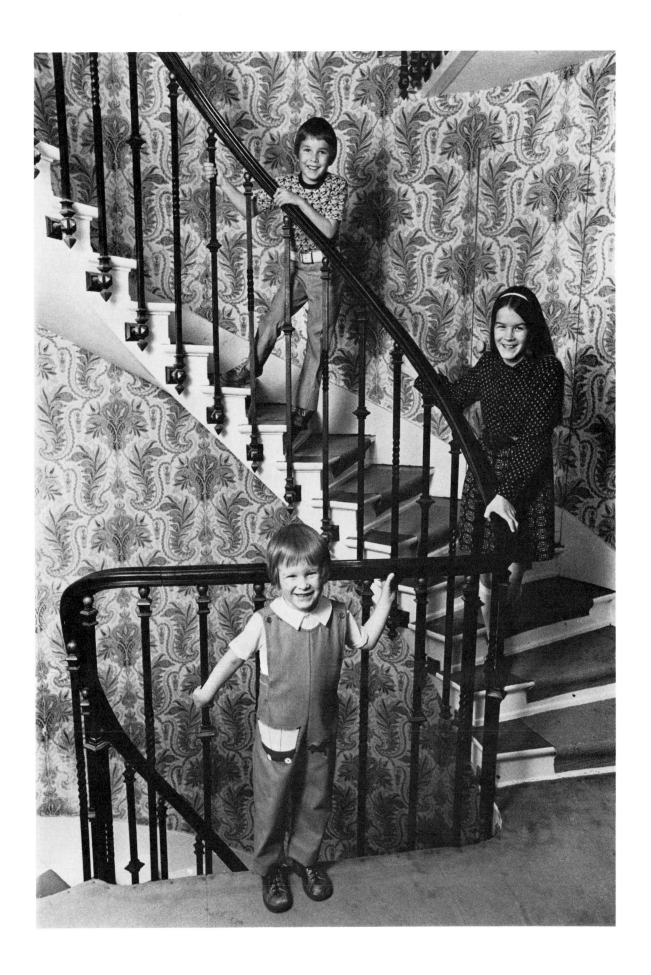

Eliminate a Distracting Background

Sometimes backgrounds are so distracting that photographing from above the subject will minimize the distraction. Also, varying the vantage angle often makes for more interesting compositions. The exception to this is photographing from below the subject. This is usually unflattering. These children, photographed outside Paris, were lit by natural light coming through a window.

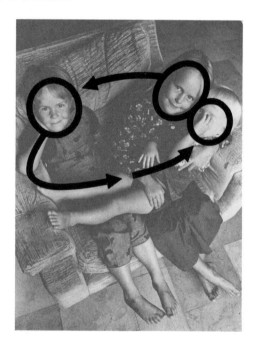

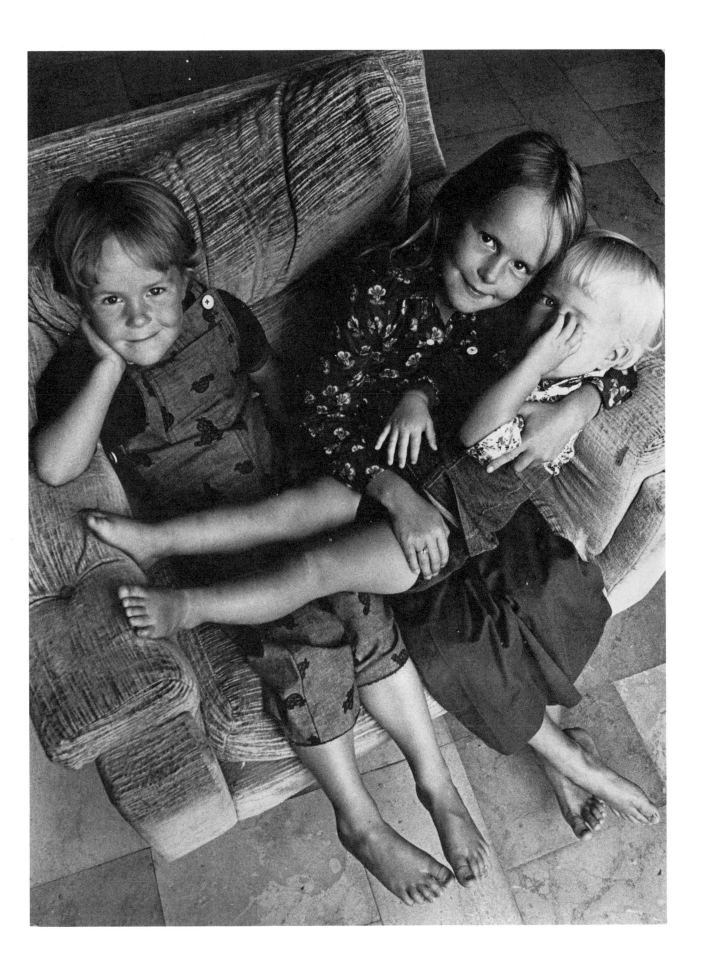

Try an Indoor-Outdoor Composition with a Wide-Angle Lens

This is an example of "indoor-outdoor" composition. The interior was lit by a white umbrella flash and the aperture determined by its intensity. The exterior natural light was overexposed one stop more than the interior to give a more natural look. The shutter speed, slow enough for flash synchronization, will affect the natural-light exposure. Once you determine the flash aperture, then by setting the camera and viewing only the exterior with your meter you can judge what shutter speed will give you one stop overexposure based on that aperture.

The side-to-side movement makes this quiet scene more dynamic. A 28mm wide-angle lens provided deep depth of field.

Here the flash was used to raise the indoor light level to the same level as the light outdoors.

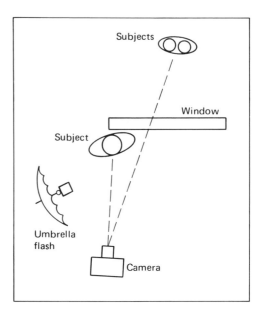

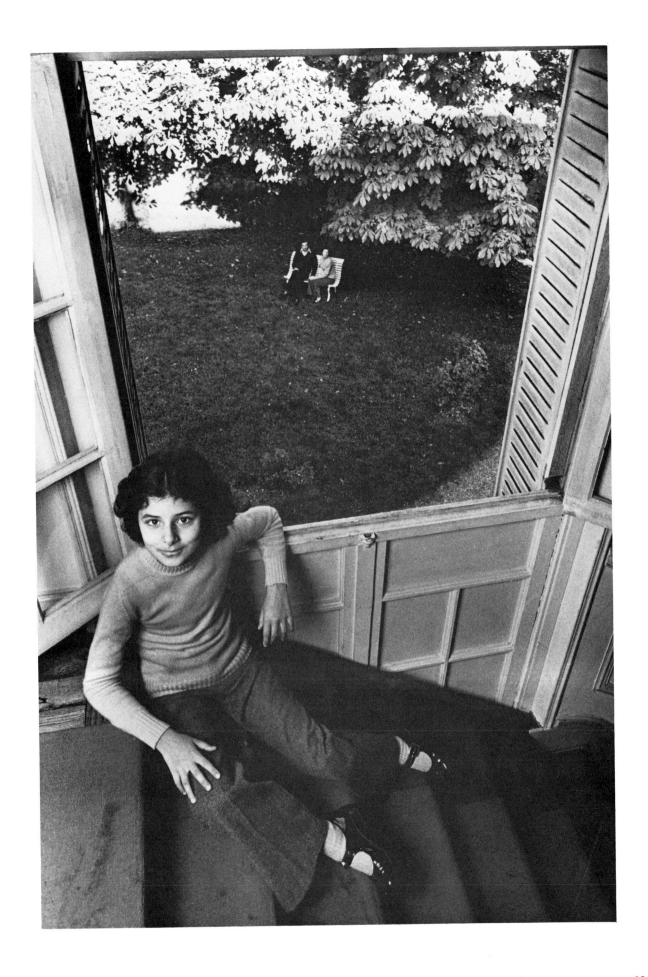

Try an Indoor-Outdoor Composition with a Telephoto Lens

This image is a variation of the preceding one. Both were taken from the same point of the same people but with different lenses. In this image the figures are given equal scale importance, whereas in the preceding one the girl was made the main subject by the scale relationship. This image, taken out of a second-story window of the house, was made with a 135mm telephoto lens and natural light. The white bench adds to the graphic impact. Changes in scale, in the figures' sizes, often make for more interesting portraits and allow the photographer, in a series, to highlight different members of the family.

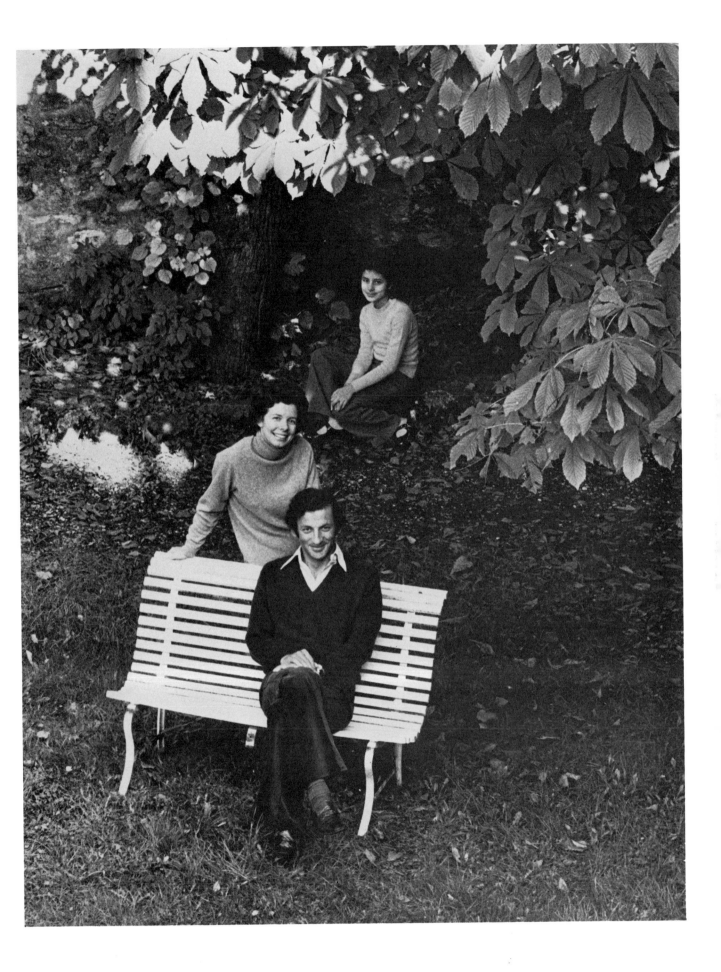

Arrange Strong Diagonal Lines of Direction

A strong parallel diagonal movement is created in this composition. The first movement involves the dog and the boy and the second is caused by the placement of the two background girls. By focusing on the dog and then on the farthest girl and checking the feet scale on the lens I was able to know exactly what range of focus I needed. By using a small f-stop (f/16) on the 28mm wide-angle lens and setting the needed range accordingly on the lens I was able to put the entire scene in relative focus with a slight bias to the foreground, which is almost always more important. Whenever you must sacrifice some focus in your range, compromise in the background where it will be less noticeable. Also, any compromise in sharpness will be more noticeable the larger you make your print. This is true for any flaws.

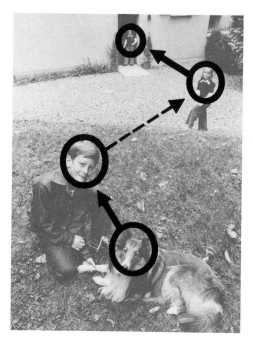

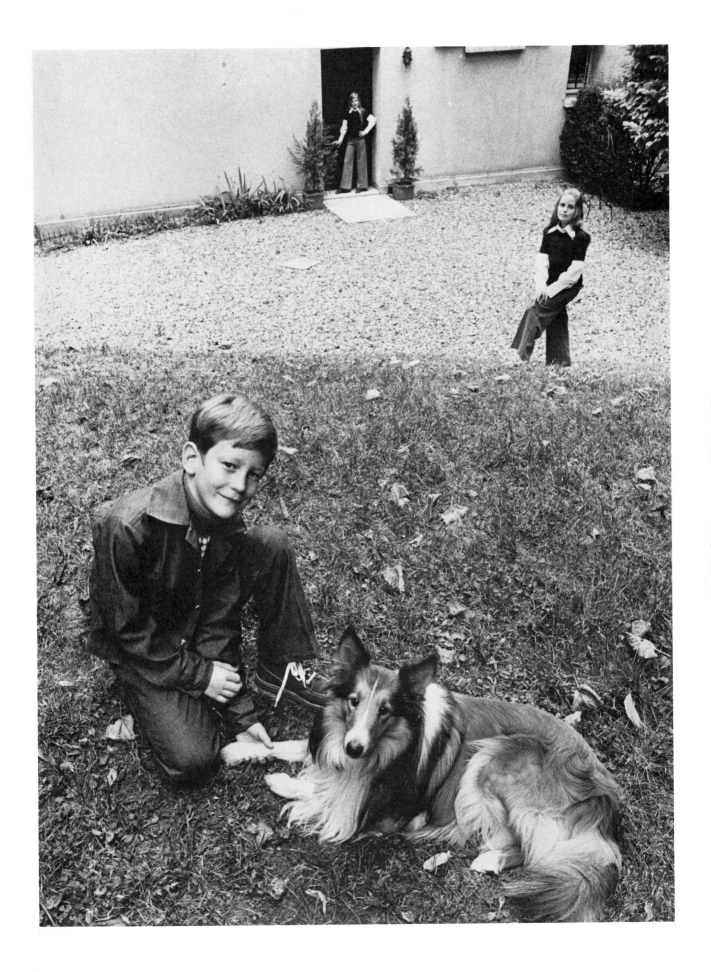

Create an Optical Illusion

This is an illusion. The children at the top appear to be on top of the wall. And yet aren't they too small? This "trick" on the viewer is played by positioning the camera on the children, who are actually standing at a distance and across a street, in such a way as to make the street look like the top of the wall.

A 28mm lens took in the entire scene nicely and provided long depth of field. The white sweaters on the girls caused tonal separation from the background.

A white umbrella flash lit the foreground parents and gave an aperture of *f*/16. The shutter speed was then set at 1/15 sec. to register the background natural light at *f*/16 also. A tripod was used.

This diagram shows the overall setup used in the facing photo.

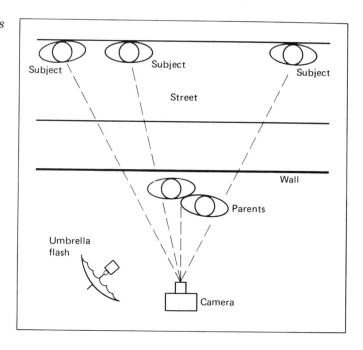

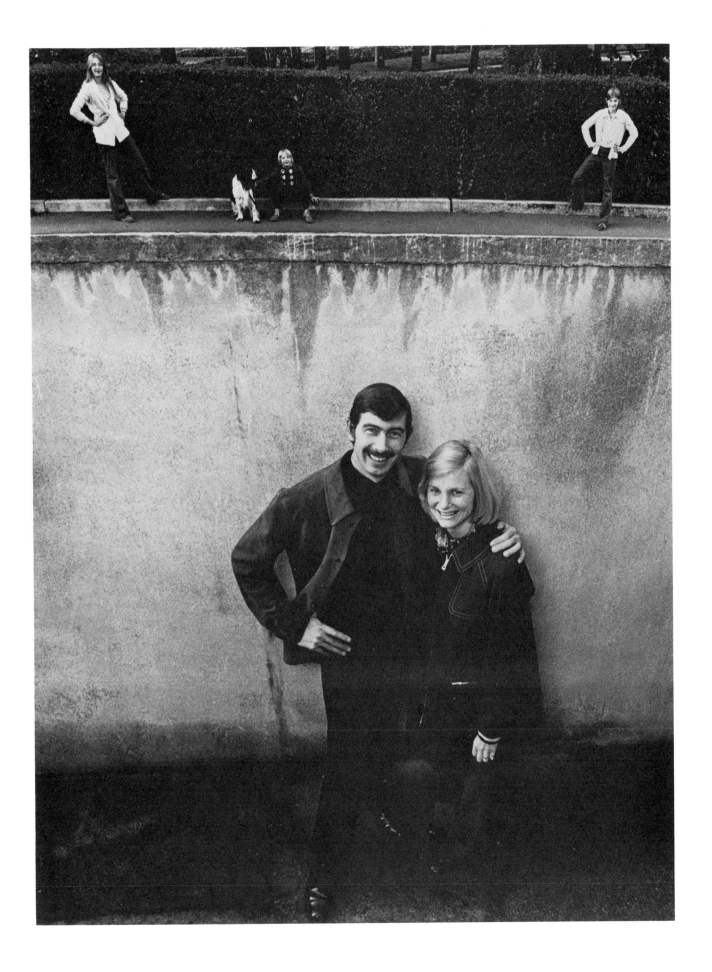

Include the Family Pet

Family pets are always a nice added touch to portraits. One must be able to work quickly, though, for obvious reasons. This carefully composed image retains a spontaneous feeling and is made stronger by the glance of the little girl to the dog. This is crucial for the circular movement of the lines of direction and adds something extra to the feeling of the portrait. The 135mm telephoto lens was used for shallow depth of field, which rendered everything in front of and behind the subjects out of focus. Also notice the strong diagonal movements.

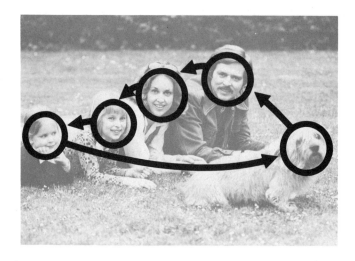

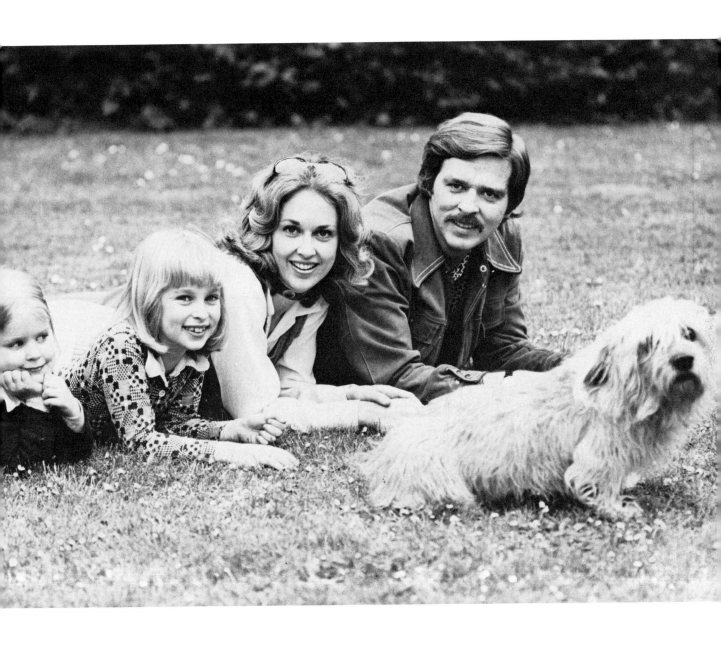

Combine Play and Picture Taking

These children, photographed in the suburbs of Paris, were not really looking forward to having their picture taken. As soon as I asked them what they thought about doing a "tree" picture their mood changed. Oftentimes children are not too eager to be photographed. They would prefer to play. If the photographer can combine the two, play and picture-taking, then everyone will be happy and it will be reflected in the results.

There is a nice circular movement in this composition attained chiefly through curves of the legs of the boys. The little boy's extension between his sisters on the bottom completes the movement. A normal lens was used.

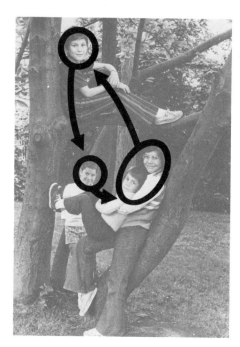

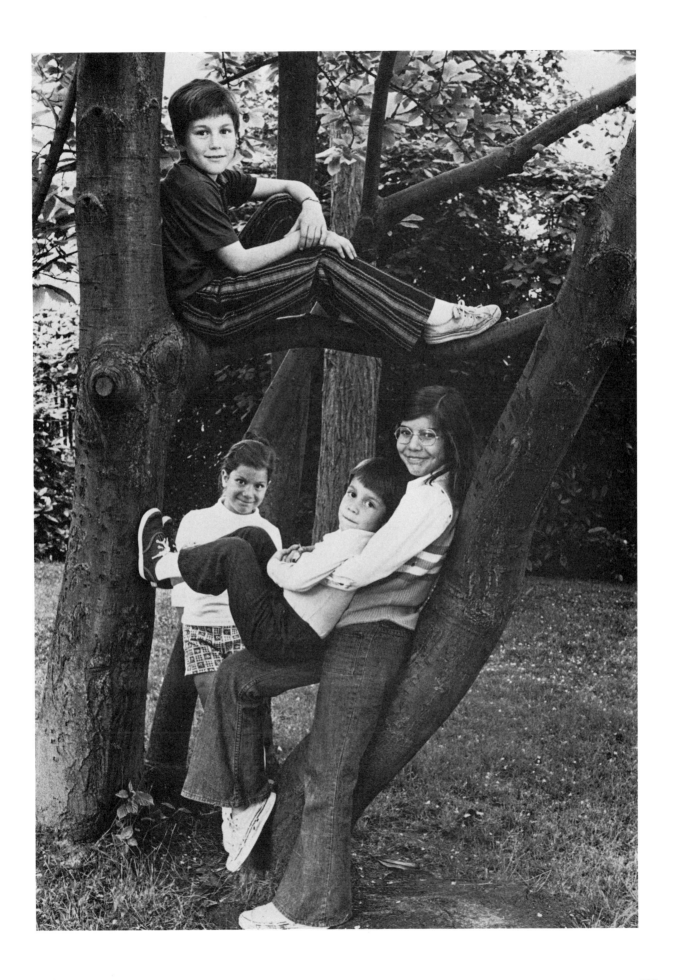

Use a Frame within the Frame

The mirror which reflects the daughter becomes a "frame within the frame." Doorways and windows also often become inner compositional frames. In order to render all the people sharp, the depth-of-field range had to include two focusing distances–the camera to the foreground people and the camera focused onto the girl–which, in effect, was the distance from the camera to the mirror to the girl. By using a small *f*-stop (*f*/16) and the depth-of-field scale on the 28mm lens, sharpness was attained. A white umbrella flash lit the foreground people and was balanced with a separate light which lit the girl, who was standing to the side and behind me. Having the girl in a light dress added to the graphic quality, giving better separation from the background.

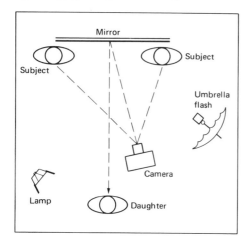

This diagram shows the two separate light sources—flash for the foreground of the parents and mirror, and the light from a lamp for the daughter in the background—used for the facing photo.

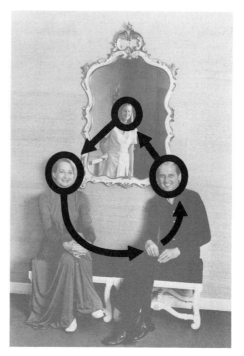

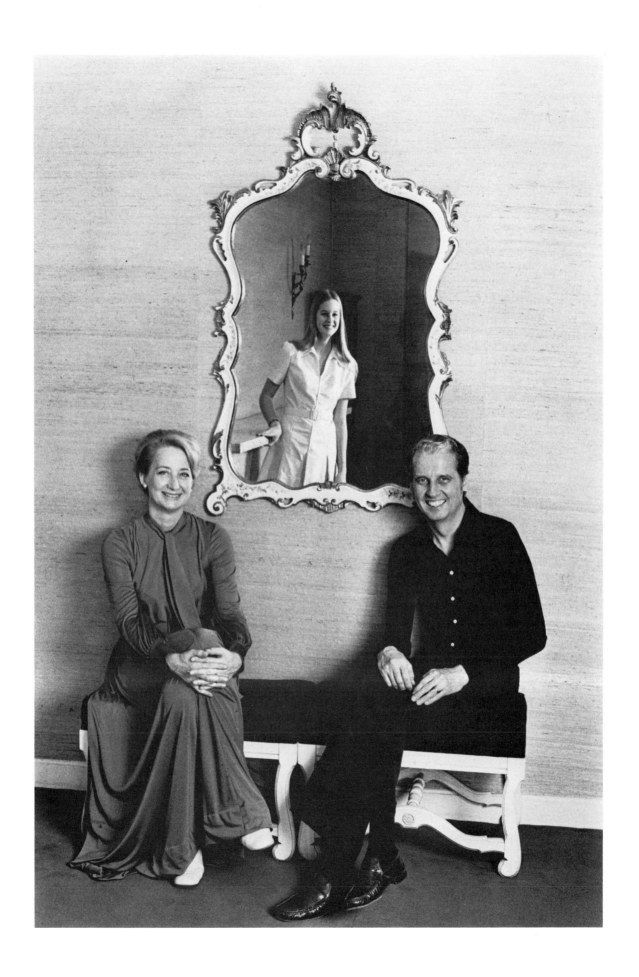

Use a Bounce Flash

I chose the kitchen of this old Paris apartment for a portrait of this American family from Greenwich Village now living abroad. I liked the circular wooden table, knowing that it would make for pleasing lines of direction. The fruit was added to the table so the scene would not look too spare. For lighting I stretched a white sheet, taped to the wall, next to the camera and bounced a flash into it, calculating the exposure from the light falling onto the people. Notice how the curved arms add to the curving lines of direction. The small space necessitated using the 28mm wide-angle lens. This caused a slight bit of perspective distortion in the boy. The top part of his body is slightly too big.

This diagram shows the lighting setup used for the facing photo.

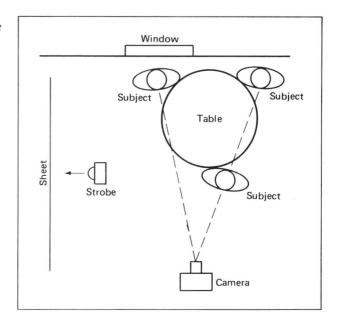

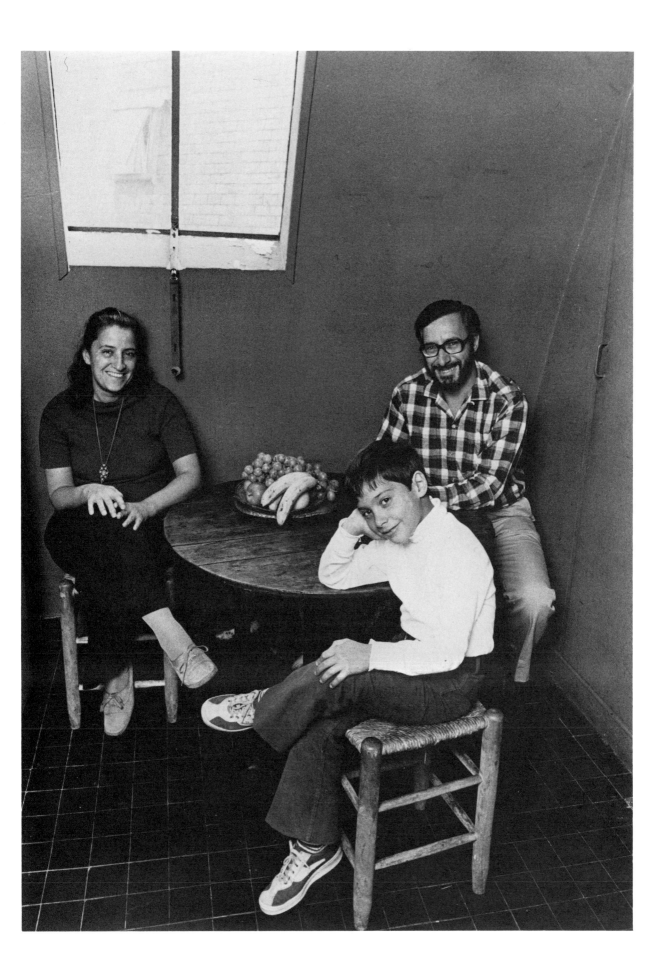

Prefocus for an Action Shot

This action photograph has added impact because of the boys' white shirts, which set them off from the background. The 135mm telephoto lens was prefocused just before the hedge, and I took the photograph when the running kids reached the spot. As it is impossible to see everyone at the moment of exposure, it is important to take extra images to be sure you have what you want. The shutter speed was 1/1000 sec. to stop the rapid movement.

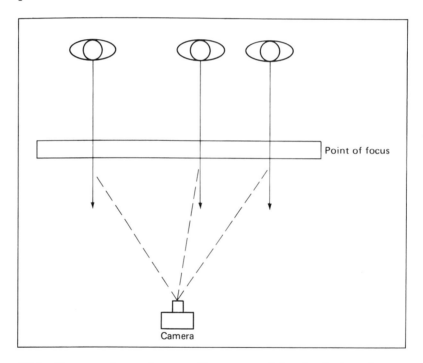

This diagram shows the overall setup used for the facing photo. The children started running toward the photographer from behind the small hedge, and the photograph was snapped at the moment they reached the predetermined point of focus.

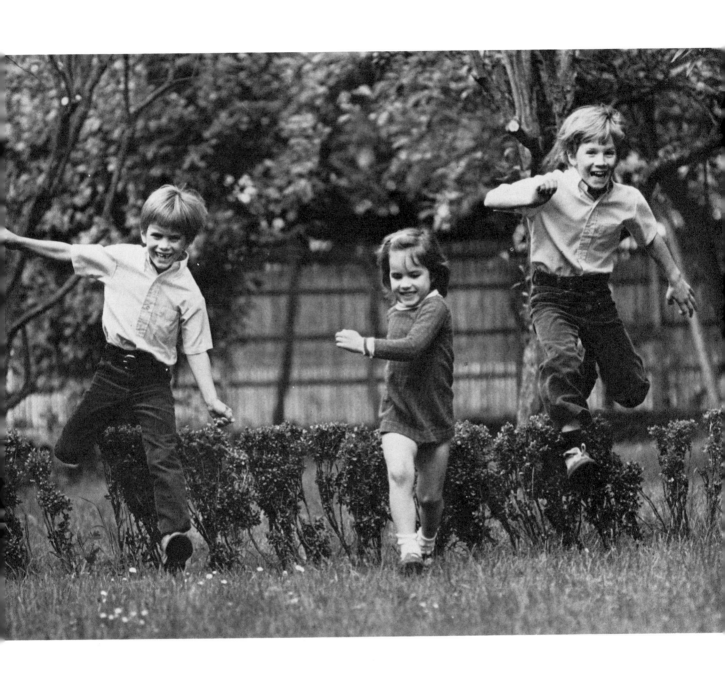

Capture a Vivacious Child

The little girl was so vivacious that it caused problems. The rapidly falling natural light at the day's end forced a shutter speed of 1/60 sec. with the normal lens wide open at f/1.4. At this speed any movement will result in blur. Normally I would have been happy to have someone so active, but at 1/60 sec. a photographer is fairly limited. Luckily she stood still for this exposure. Her little friends, standing out-of-focus in the background and much smaller, make it a little more interesting. By using the depth of field preview button you can see exactly what out-of-focus things will look like. This is important to know ahead of time.

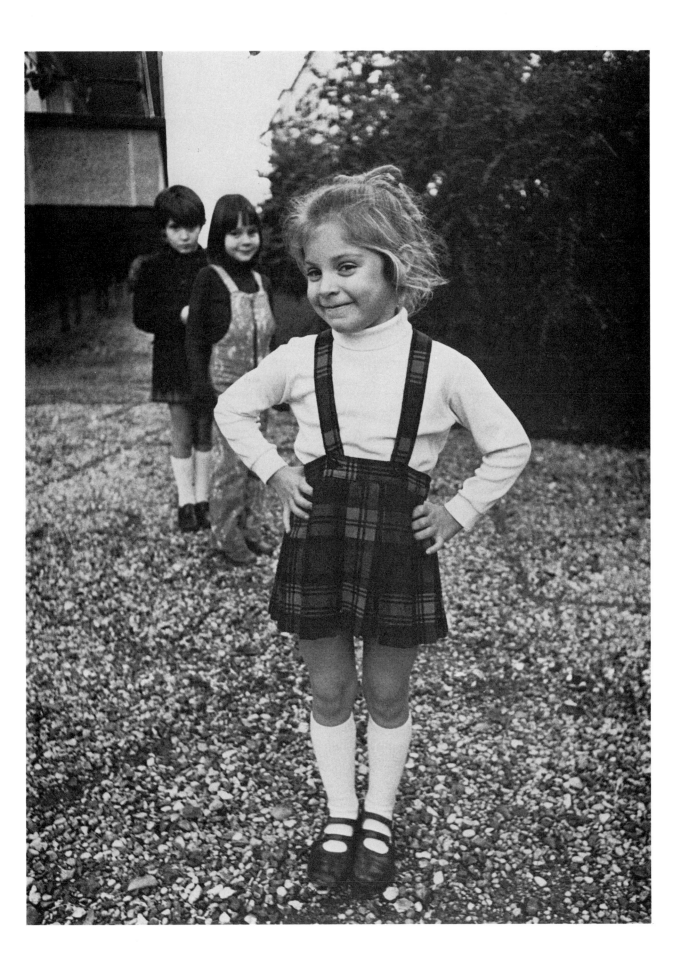

Pose a Family Carefully

I often find it interesting to play with scale changes. In this case the smallest member of the family becomes larger because of his placement in relation to the rest of the family and to the 28mm wide-angle lens. This American family, living in Paris, created an atmosphere of New England, their place of origin. The reflection of the girl in the table is an added touch. The white walls provided a perfect reflective surface for bouncing a flash. The parents were carefully placed so that no picture frames on the wall would "grow out" of their heads. The photographer should always notice the space directly around a subject's head and try to avoid distractions.

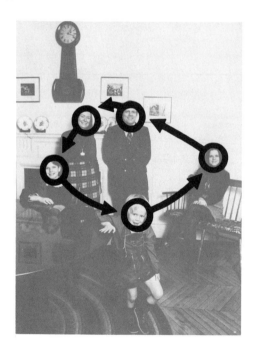

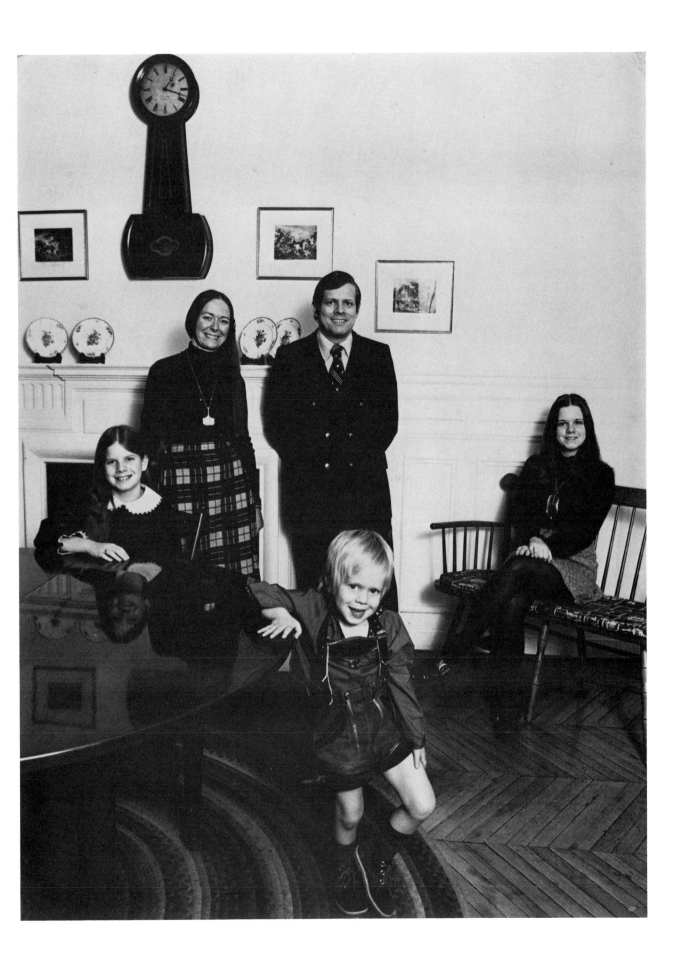

Use a Counterbalance

This American family from the Midwest, living in Paris, were photographed on their balcony. The railing formed a nice curved separation in this slightly unorthodox composition. In order to have everyone on one side of the frame I needed a strong counterbalance. The buildings across the street provided this. The little boy looking down added another dimension. The railing also directed the viewer's eyes to the people. A 28mm wide-angle lens was used in daylight.

127

Use Natural Frames

Situated in the town of Versailles, this little house provided a nice back-drop for a portrait. I used the natural framing of the window and door. The lighting was available light except for a backlight behind the father and son. The white curtains were drawn behind the woman to cause separation from her dark blouse. Also, the overhead lamp was lit to add graphic impact. The baby's white dress is nicely separated from the woman's dark outfit. A normal lens was used hand-held.

Create Depth and Strong Composition

The mayor of a small town in Normandie commissioned me to photograph him, his wife, and children. I placed the parents on a small bridge and then used the background tree to counterbalance the couple. I had the boys wear light sweaters for added separation from the background. The branch on which the boy sits adds to the power of the counterbalance. The line of the railing of the bridge also helps lead the viewer's eyes into the image and toward the children in the background. The 28mm lens was used to render everything sharp.

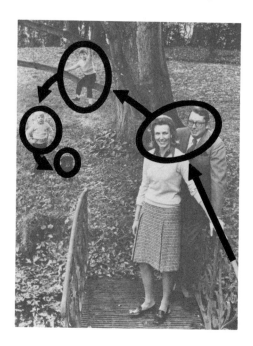

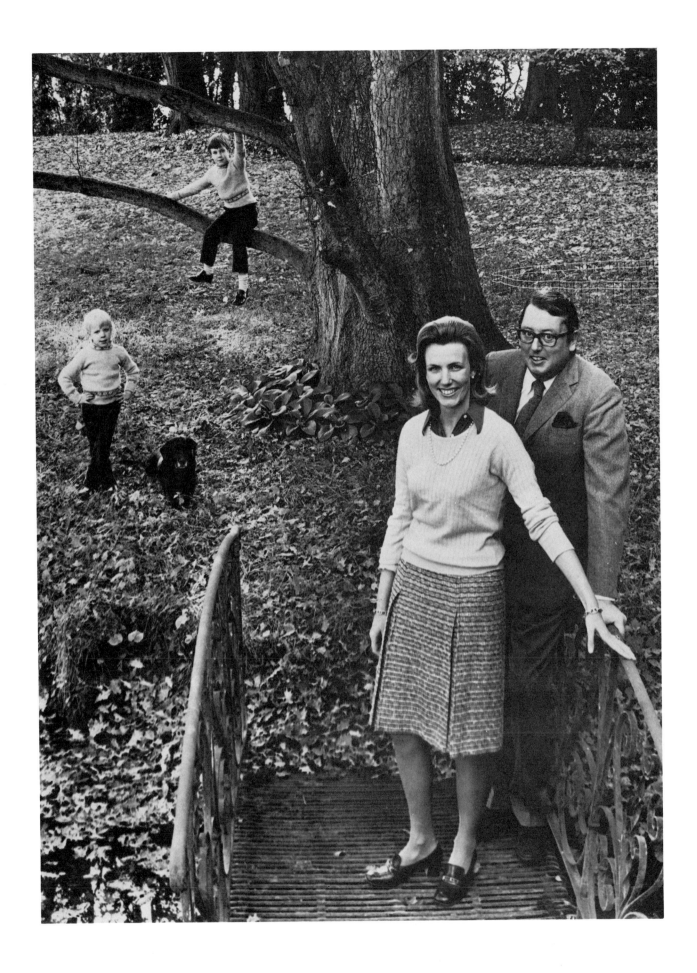

Experiment with a Wide-Angle Lens

These children, the same as in the preceding image, were photographed around the château, the little boy on the balcony and the older one in the back driveway. The wide angle lens allowed me to keep both boys in focus, sacrificing a bit of perspective distortion in the foreground boy. This is caused by tilting down the wide-angle lens, making the top of the boy slightly larger than the bottom. The swirl in the metal work is used to frame the background boy. The dog, as usual, adds a nice touch. The small aperture, because of the depth-of-field requirements, forced me to use a slow shutter speed (½ sec.) and a tripod.

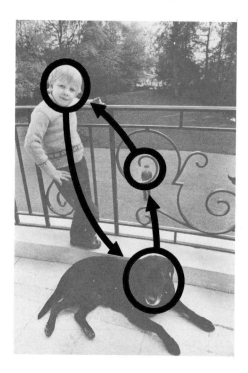

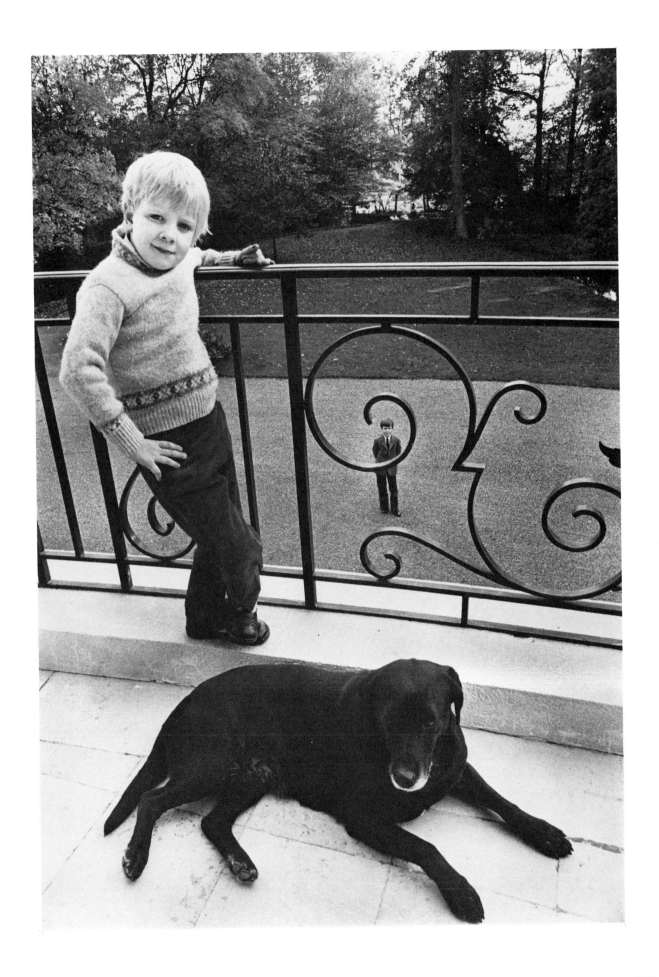

Expose Carefully When Including Water

These friends of mine were photographed at a small lake in upstate Connecticut. The water provided a fun element in the composition. The lighting, however, was tricky. The pier was in shadow, so I was forced to use a portable white umbrella flash setup to light the parents. This light was balanced with the natural light illuminating the children. The wide-angle lens allowed for the deep depth of field. Because of the strong specular reflecting highlights you must be careful not to underexpose pictures done around water using natural light. Take a closeup skin tone reading and judge accordingly.

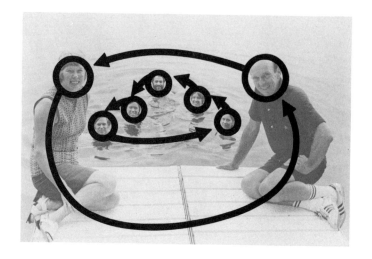

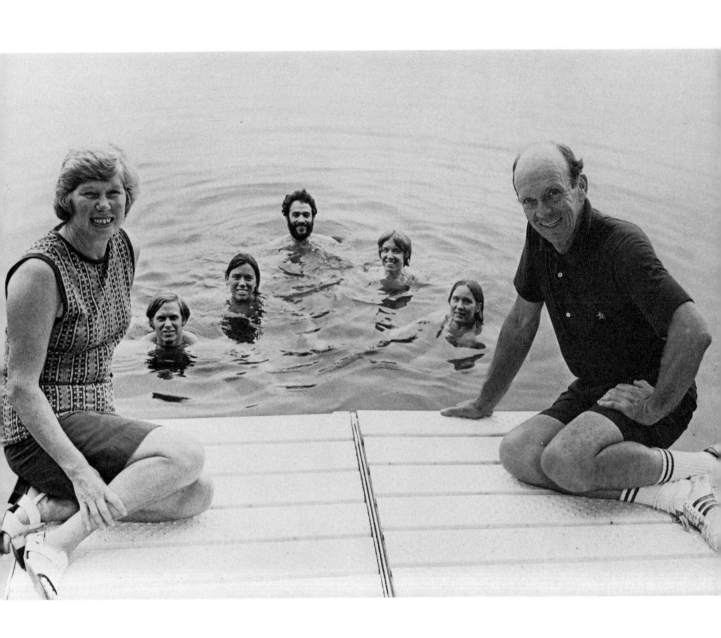

Emphasize One Person in the Family

This portrait emphasizes the small girl. The lines of direction lead your eye to her. Her parents and brother are thrown out of focus intentionally. To check the appearance of this out of focus the depth-of-field preview button was used beforehand. The diagonal white line of the slide brings your eye right to the girl's face. A normal lens was used and the figures carefully posed. The lighting was daylight.

When doing a series of family portraits you can vary the "importance" of the people by changing their relative sizes from one image to another.

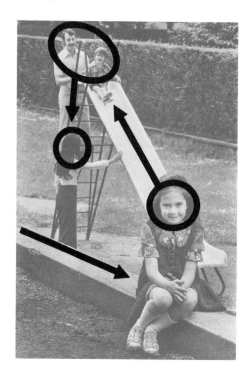

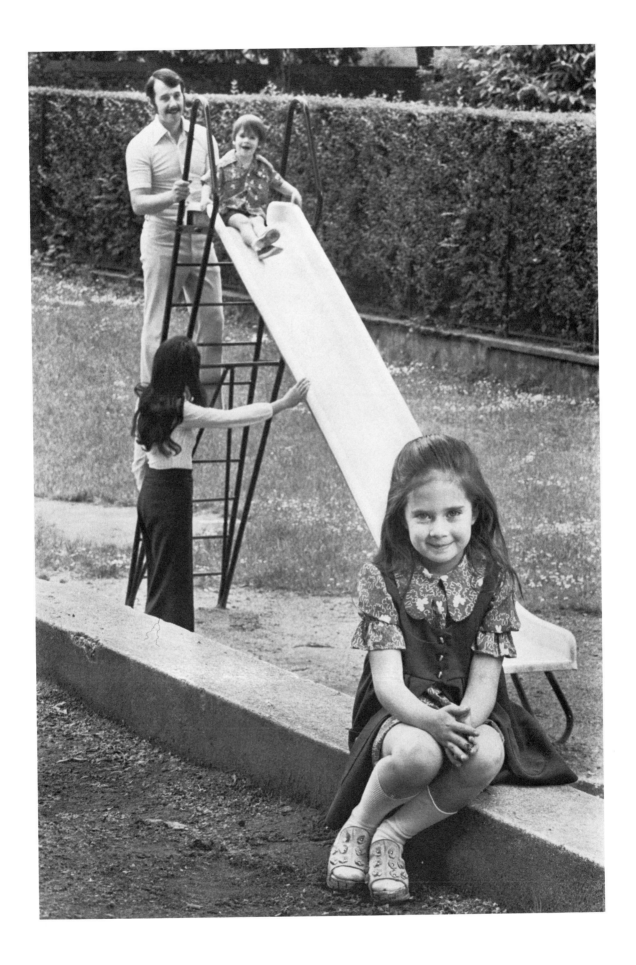

Experiment with the Self-Timer

This self-portrait with friends was taken using the self-timer on the camera. First the 135mm telephoto lens was prefocused and set according to the natural light. The timer was primed to go off in 10 seconds. The camera was on a tripod. The couple was positioned on the stairs. I set off the timer and ran onto the stairs. The shutter speed was set for 1 second. As the shutter went off I hesitated and then moved down the stairs. The hesitation caused the sharpness but the movement caused the blur. The ghostlike effect is caused by the background exposing onto the film after I have moved. This double exposing causes the translucency.

The white window frame becomes a strong inner frame and the stairs add a graphic diagonal movement.

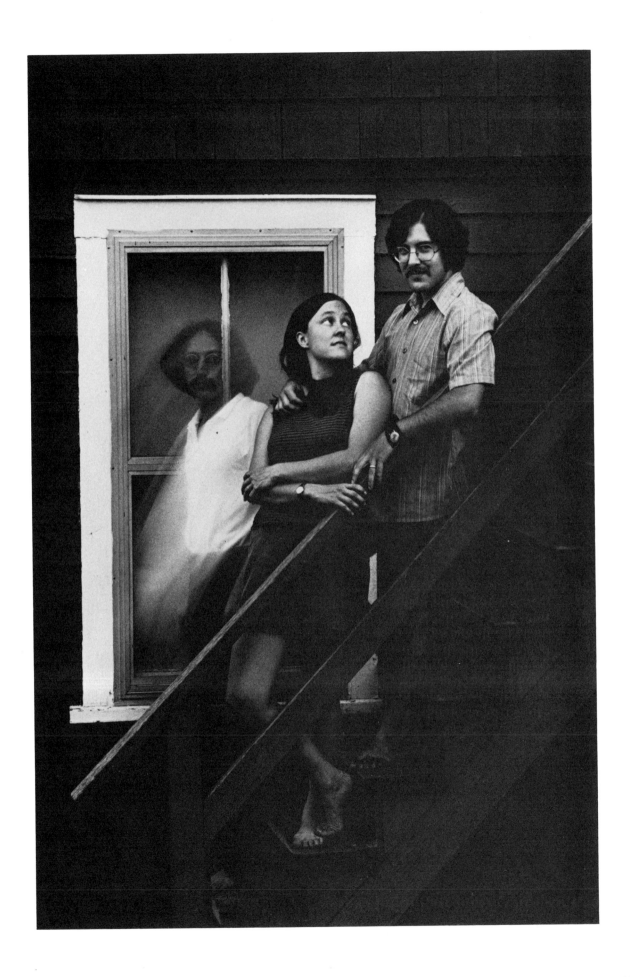

Index